REMEMBERING
SYRACUSE

REMEMBERING SYRACUSE

DICK CASE

Published by The History Press
Charleston, SC 29403
www.historypress.net

Copyright © 2009 by Dick Case
All rights reserved

All images are courtesy of the *Post-Standard* unless otherwise noted.

First published 2009
Second printing 2012

Manufactured in the United States

ISBN 978.1.59629.583.4

Library of Congress Cataloging-in-Publication Data

Case, Dick, 1935-
Remembering Syracuse / Dick Case.
p. cm.
A collection of Dick Case's "Neighbors" columns first printed in the the Post standard.
ISBN 978-1-59629-583-4
1. Syracuse (N.Y.)--History--Anecdotes. 2. Syracuse (N.Y.)--Biography--Anecdotes. 3. Syracuse (N.Y.)--Social life and customs--Anecdotes. 4. City and town life--New York (State)--Syracuse--Anecdotes. I. Post-standard (Syracuse, N.Y. : Daily) II. Title.
F129.S8C35 2009
974.7'66044--dc22
2008050261

Notice: The information in this book is true and complete to the best of our knowledge. It is offered without guarantee on the part of the author or The History Press. The author and The History Press disclaim all liability in connection with the use of this book.

All rights reserved. No part of this book may be reproduced or transmitted in any form whatsoever without prior written permission from the publisher except in the case of brief quotations embodied in critical articles and reviews.

CONTENTS

Introduction 7

PART I. History Lessons 9

PART II. Hot Dogs and Sausages 35

PART III. The Soldier and the Priest 65

PART IV. Flowers and Neighbors 91

INTRODUCTION

Years ago, in graduate school, a professor introduced me to an idea that a mentor had shared with him years before: There are certain people and events that fall below the level of historic scrutiny. It's up to you to find them.

That's been my big calling through the years, about fifty, as a writer for the Syracuse *Post-Standard* and *Herald-Journal*—to find people and events that dropped between the cracks of history. Like gems hidden at the bottom of a mine, they don't sparkle until you find them and bring them to the light. These are the sort of folks who lit up my life through a career. They own the small stories that don't make headlines. They rest there, waiting to be mined.

My hometown of Syracuse has thousands of these stories. When I started writing my column, it was part of my charge to find the stories that weren't the stuff of big news but were interesting nonetheless. I've gathered a few together for this book.

At the very beginning, back in 1979, I made a list of possible columns. Not all of the ideas lasted to a finished product, but the list soon dried up. I was able to keep the column going with ideas from my readers and my own curiosity, chasing "history on the run."

Looking back on all of those columns, it's quite a harvest, good and bad. Some pieces stand up to the test of time; others fade quickly, like flowers that get too much sun.

Some of the columns in this book reflect my interest in history. When possible, I try to give the story its proper setting in time, adding a few facts to the current event. In that work, my friends at the Onondaga Historical

INTRODUCTION

Association have been steady and helpful companions. The reader will notice that some of the articles add bits and pieces of local history. They are not served all at once, the way a historian might do, but in little portions, to be savored and enjoyed.

The stories drift across a broad spectrum, from John Wilkinson, the man who named our city, to Bill LaMirande, the artist who painted our picture, sometimes capturing a moment with a brush stroke.

You'll read about Jonathan Bailey, a soldier in Iraq; Roy Simmons, the artist and lacrosse coach; Giovanni Gianelli, the craftsman in wood; Jimmy Smith, the short-order cook; Nick Morina, the barber; Ray Rinaldi, the boxing coach; and Father Joe Champlin, the remarkable writer-priest who died last year after a long fight against a disabling disease.

There are sad tales like those of the tossed-out dead babies and the missing professor, and there are joyous elements such as the reopening of the Palace, the neighborhood movie house, and the Asciotis, the happy makers of meatball fixings.

Sheltered in one book, all help to tell the story of our town. There are many more to be revealed.

Dick Case is a columnist for the Syracuse Post-Standard, *where the originals of these columns appeared. Text and pictures are reproduced with* Post-Standard *permission.*

PART I
HISTORY LESSONS

THE ARTIST

Bill LaMirande is the retired General Electric Company guard who lives on Lydell Street in a town neighborhood called Skunk City. He recently found himself as an artist. He works at it every day. Actually, Bill's been painting and drawing for forty years. He put in thirty-five watching over Electronics Park. So, I said to him, "Art was a hobby, all that time."

"Wrong," Bill thundered in a very polite way. "Guarding was a hobby." We laughed. "I always wanted to become a painter," he said.

We were in the basement of the LaMirandes' little yellow house at that moment. Here the artist stands, in front of a workbench, looking up at his driveway through a window, and perfects the watercolor sketches that threaten to take over the building that Bill, his wife, Ann, and daughter, Amy, call home. The studio is a LaMirande gallery. Likewise are much of the first-floor kitchen, dining and living rooms.

"There's a ton in the attic, too," Bill explained. I believed him. "My first one was a copy of a Cézanne. After that, they just kept coming and coming." The man likes what he does, and it shows. "You imitate others for years and years, and then you finally become yourself, and you're amazed at what you've become," he said.

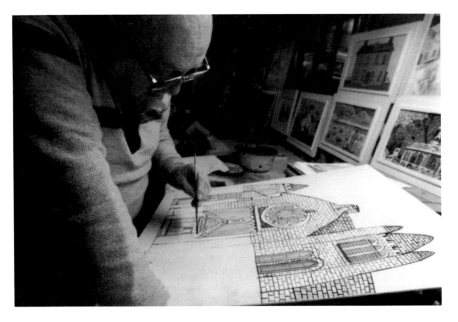

Artist Bill LaMirande works on a painting at his Skunk City home.

Bill's surprised at our interest in what he's able to do on that modest sketch pad of his. He's amazed that someone is willing to pay money to put an original LaMirande on his own wall. He's amazed that a Syracuse gallery recently decided to show his work. I was introduced to a few of what you might call Bill's town sketches at Artifice Gallery, 223 Walton Street, in Armory Square. Catherine Gottlieb opened her shop in September "to show things that might not ordinarily be seen in Syracuse." Bill walked in off the street with a packet of fifty or sixty of the watercolors he's been doing the last couple of years. Catherine told me that she liked what she saw. "I think his art is wonderful," she says.

I recommend stopping by the gallery to check out what Bill's up to here. My computer comes up short explaining the sketches. If you leaf through a packet, the way I did the other day in Bill's living room, you might think you're looking at the same imaginary street winding up to a horizon over and over again. Look again, and you notice that they're different, each one. Variations on a theme, according to their creator. No, he explained, this is not a particular street, although people tell Bill that they recognize landmarks in his sketches. Even the names we see on the store signs are fantasies.

Memories moved Bill. "The streets are from memories I have as a child," he explained. "I remember the whistles blowing and the smell of coal gas in the air and the workers going to work. Those memories move me to paint."

History Lessons

Bill grew up on Gertrude Street. His father was a plumber. Later the family moved to Eastwood. He attended St. Vincent's School and Vocational High School. He never had a lesson in art. Why bother, Bill asked, when you can learn your own lessons at your own pace? As a kid he'd draw World War I airplanes on his school papers. He liked to read art books. His uncle Jack O'Connell, who knew local artists and had their works in his home, encouraged him. One time Jack showed Bill a copy of *Life* magazine with reproductions of the paintings of the nineteenth-century French artist Paul Cézanne. He took "one look at those and said, 'That's what art's all about.'"

The Frenchman had the kid from Syracuse in his grip the next few years. Bill spent his time copying Cézanne and producing variations in his drawings. He married Ann in 1951. "One day I said to him," Ann recalled, "that we needed something to hang on the wall. Why not paint a picture? Well, I should have bitten my tongue. Now we have to fight for space on the walls." Bill smiled. Ann smiled. I looked around the living room. Bill had three walls and Ann one for her needlepoint. The compromise pleased them.

It took Bill years and years to find his own style. He told me that he haunted museums, searched art books and "tried every ism there is" in search of the one with his name on it. Along the way, he produced some very polished work in pencil and charcoal. *Post-Standard* art critic Gordon Muck saw a piece of Bill's at the On Your Own Time exhibit and praised it as "sensitive." In 1977, Bill painted a large mural called *People of the World* for Bellevue School. He won prizes and clients bought his work. He drew a cover for a G.E. engineers' magazine. Bill showed me one of his '70s sketches. It's his daughter Amy's favorite, *Shiloh Letter*, a drawing of a Civil War soldier. Bill's own favorite of that period is a sketch of Amy.

But this style wasn't Bill LaMirande. He said that he discovered the artist he wanted to be about three years ago. Bill can't fix the revelation at a particular moment, but he said that he began to see his interest in Syracuse history merging with a technique that became simpler and simpler. It just happened, he said. He wanted me to notice the simple directness of children's art. He likes children's art very much. That's why he spends a lot of time working with one of his grandchildren, Tommy LaMirande, age ten. There's a room off the kitchen where the two artists paint. Tommy's works line the walls. They're remarkably like his teacher's.

Down the cellar stairs in Bill's studio, paintings are stacked everywhere. Most, Bill told me, were done in the last two years. I'm looking at plenty of buildings, many of them local, which he paints from memory and photographs. I mentioned that he favors bricks. "I like factories," he replied.

"I'm becoming a Syracusan. I'm very interested in history." I saw that, around me. Just about every Syracuse church of an age is there. "Steeples, steeples," Bill explained. He likes them, too. Also, the old Zett's brewery, the brewery at Rock Springs, the Weighlock Building, the State Fair, the paper company at Martisco, city hall, Sylvan Beach. And the faces of salt makers, bread bakers, barkeeps and Tony Romano, the North Side artist Bill knew and loved. Tony, who was a laborer at Easy Washer, found himself as a hometown artist, too. He died in 1966, and Bill did his portrait. It hangs in the dining room.

Bill's watercolors begin with a sketch in pencil and end when he's satisfied that he's got the mood on paper he felt when he started. That may not happen quickly. He'll put a work aside and come back to redo it weeks later. Whatever, the result's Bill. "You know," he said, "you really don't come up with your own style until you forget all the theories and all the other painters. Once you become yourself, you ignore everything else."

Originally published in 1992.

A FOUNDING FATHER

Bleat even now the earth, since wonderful Nature scatters so much wealth about and from her lap pours forth so many delights. So that thou, oh city, with the spirits and arms of thy citizens, need consult only for thy fame.
—From the epic poem, Syracuse, *by Edward Stanley, John Wilkinson's inspiration for naming the city.*

The other day, I took hold of the bloodline of one of Syracuse's founding families and followed it to Jack Wilkinson's comfortable home on Onondaga Avenue, minutes from downtown. Jack is John Wilkinson III, a Unitarian-Universalist minister, airborne infantry platoon leader in the Korean War, actor, storyteller, activist to legalize illegal drugs and great-great-grandson of the man who named our city and helped to win Syracuse's charter in 1848. He was John Wilkinson, too. Thanks to that earlier Wilkinson, we celebrate 150 years as the city of Syracuse, not Corinth, among other legacies.

Jack, who's lived here most of his life, keeps the family flame burning. We don't have that many representatives of the charter mothers and fathers still among us. Actually, we need to jump back yet another generation to find the original Wilkinson pioneer in Onondaga County. Our first John Wilkinson was a Revolutionary War veteran from Rhode Island who was said to have walked here from his home in Troy, leading a cow next to the ox-drawn wagon in which his family rode. He bought a farm a mile from Skaneateles Lake in 1799, along what became U.S. Highway 20. John was killed in a fall from his barn just three years later, at the age of forty-four. The Syracuse name-giver was his son. Seven years ago, Skaneateles reburied the remains of John and his wife, Elizabeth, in the family plot at Lake View Cemetery. They'd been discovered accidentally and rested at the county morgue for twenty years.

Wilkinsons seemed to have been born with strong legs and a will to walk. We're told that every week young John walked from Skaneateles to Onondaga Academy in the Valley about thirteen miles one way, so he could get an education. Later, he studied law with another of our pioneers, Joshua Forman, and helped lay out the new village of Syracuse while on a surveying team. In 1820, John built a law office at Salina and Washington Streets, at a

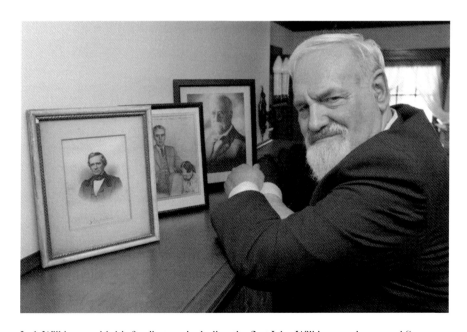

Jack Wilkinson with his family tree, including the first John Wilkinson, who named Syracuse.

time when "there were no other buildings there, and his plot neighbored a forest," according to a family history.

John seems to have been as busy as his great-great-grandson is today, in different ways. He held political office, ran railroad companies and the Syracuse Water Works (Wilkinson Reservoir, now Hiawatha Lake in Onondaga Park, was named for him) and in 1820, when our first post office opened, became postmaster, a job he held for twenty years.

Historians tell us our name evolved from the earliest Bogardus Corners, after a tavern on Clinton Square, to Milan, South Salina and Cossitt's Corners. The name Corinth as a post office came from John's mentor, Joshua Forman. It had been a favorite of his because he read his Greek history. Corinth it was, until the new postmaster sent his paperwork to Washington. It came back accepting John Wilkinson but rejecting the suggested name—we already had a Corinth in New York, in Saratoga County. John would try again, this time with a name he recalled from his own reading, Syracuse (Siracusa in Italian), a port city in Sicily. There's an interesting story about that.

It seems that the young lawyer had been visiting a friend in New York City and started reading in the man's library. One book was a collection of Oxford University prize poems. John would say later that he was taken by one, translated from the original Latin by Edward Stanley. Stanley's epic went on and on about ancient Syracuse, a city on a lake fed by cold springs in which fresh- and saltwater mingled. A nearby town, Salina, was mentioned. So were the statesmen Cicero and Marcellus, and Messina, the local name of a settlement at the east end of our James Street. John took his idea to village leaders. Syracuse it was. For good, this time.

I borrowed details of the life of John Wilkinson from the book of family lore written by his great-granddaughter, Mary Van Duyn Hill, Jack's mother. This wondrous Syracusan, who died in 1993, carried more first family genes into the stream. The book is *A Letter From Toto: Remembrance of a Syracuse Family*, published by her cousin Trudy Eiler's Pine Grove Press.

Jack, his brother Ned and his sister Hope track lines back to the Leavenworths (Elias was mayor of Syracuse two different times), Beldens, Formans and Van Duyns. Their grandfather, another John, invented the air-cooled engine used in Franklin cars. Their father John, also an engineer, invented a machine to speed the production of bullets.

A distant cousin of Mary was Jennie Jerome, Winston Churchill's American mother. She even connected to Jemima Wilkinson, who founded a religious sect near Penn Yan early in the last century. Jack himself is a big,

unassuming guy who lives in a house designed by Ward Wellington Ward. It's filled with books, papers and family pictures.

He says he was "bitten by the theatre bug" while in college and majoring in Hispanic-American studies. He enlisted in the army airborne, did a tour in Korea under General William Westmoreland and returned to study drama with the legendary Sawyer Falk in a Syracuse University graduate program. Among other roles, he played Ben opposite another local theatre icon, Ken Bowles (as Willy Loman), in *Death of a Salesman*. Jack's a regular in Syracuse amateur theatre productions, from *Dairy of Anne Frank* to *Blithe Spirit*, and a regular letter-to-the-editor writer on such subjects as welfare, Anita Hill and flag burning.

Unitarianism has been a tradition among Wilkinsons since the days of Great-Great-Grandfather John, who was on the committee that welcomed the Reverend Samuel May, the famous minister and abolitionist, to Syracuse in 1843. The pastor's daughter, Charlotte, married John Wilkinson's son, Alfred. Jack started to study for the ministry when he was thirty-four. He had congregations in Massachusetts, Tennessee and Little Falls and sometimes sermonized on one of his interests, the legalization of drugs, a subject not all of his parishioners wanted to hear about. He feels that, from a theological point of view, we face a choice among good, evil and freedom of choice. "It's a complicated journey," he explained. Jack is an active member of a local group called ReconsiDer, which believes that the so-called war on drugs has failed and we need a substantial change in United States drug policy. He helps distribute videos of the group's cable TV shows and a new quarterly newsletter.

Another of his enthusiasms is Syracuse Storytellers, a group of gifted yarn-speakers that gives performances around the county. Jack is a featured teller. He also has one-man shows in which he gives readings in the character of poets Robert Frost and Rudyard Kipling. Three children and a granddaughter carry on the line: John IV, who is a research biologist working to find a cure for cancer; Wells, who runs a social activist group in Boston; and daughter Heather, a PhD botanist, who lives in Kentucky. Jack's brother Ned is a Connecticut business executive. His sister, Hope Yeager, lives in North Carolina.

Originally published in 1998.

THE PALACE

Alfred DiBella came to the United States from Italy in 1905, moving to New Jersey, then Canastota and finally to Syracuse, where he practiced his trade as master carpenter. In the 1920s, he started building homes along Midler Avenue in the village of Eastwood. In 1924, he bought a lot at James Street and Stafford Avenue that his family remembers as swampy, with a bit of a slope. There he raised his monument: a business block of brick with a "picture show" and four stores on the street, offices and a dance hall above the picture show. Alfred's block is seventy-five years old this month.

He called it the Palace, home to what is very likely Syracuse's oldest surviving neighborhood movie house, still in the DiBella family. The builder's daughter, Frances DiBella, has run the Palace since her father died forty years ago. Both Frances and her theatre are landmarks of our town. The Palace has plenty of pride going for it, although getting Frances to talk about that is like asking if I could take out her appendix, even on this grand anniversary. Forget about taking her picture. Her sister, Alfreda "Freda" Heagerty, who also grew up around movie houses, has a fix on what the Palace means: "This is a real theater, a piece of history." Freda knows that her dad made good on the immigrant's American dream promise that slithered away from others.

His daughters talked to me about what's happened in this heart of Eastwood as we walked around the dark house where 1,200 people could watch a movie or an amateur show and, in the old days, win a set of dishes, a bicycle, a bag of coins or a bingo jackpot. "You know," Freda said, "it's still possible, even today, to make a niche in the world, if you're willing to work for it. After he got here, my father never wanted to go back to Italy. 'America's my home,' he'd say."

Eastwood was two years away from voting to become part of Syracuse when Alfred built his Palace on James Street in 1924. The village had been incorporated in 1847. The main drag and community center were east, around Midler and Burnet Avenues. Alfred must have guessed that annexation, which had been in the wind for years, would mean a change of focus for Eastwood, to the busier James Street that unrolled from downtown Syracuse. He guessed right. A while after he built the theatre block, he put up a business-apartment building across James and named it for Grace, his wife.

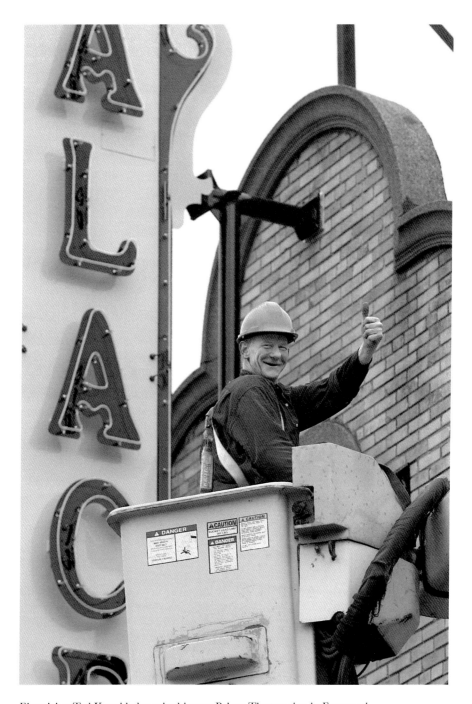
Electrician Ted Kunzi helps raise his new Palace Theatre sign in Eastwood.

Freda says that Alfred's original idea was to lease the movie house, but when the man who said he'd do that moved on, "that left Dad with the space, so he had to do it, and he did. He didn't have much education, and he spoke broken English in the beginning, but he was in the theater business." Alfred installed an organ and piano and asked Grace, who was a seamstress, to sew panels and drapes. Later he opened a candy store on the corner, Palace Sweet Shop, and rented space to a barber, lawyer and grocer. He had a real estate office upstairs. The space around the theatre auditorium would later be remodeled as apartments. The mural of film characters above the doorway to the auditorium was done by the DiBellas' most famous tenant, artist Robert Hofmann.

The only time the DiBellas stepped back as owner-operators of the Palace was in 1939, when they briefly leased to RKO-Schine and ran a small theatre in East Syracuse called the East. Later they had the Happy Hour on North Salina Street, where Freda and Frances pitched in to help their father. Frances bought the Palace from her mother after Alfred's death and has run it ever since, with the help of a projectionist or two, including her brother-in-law, Pat Heagerty, who retired after teaching school for forty years, and Joe Detor, who's been running the Enarc carbon-lit projectors since 1960. Joe also sells candy while Frances works at the ticket booth before the shows.

"I got interested in the movies when I was an usher at Loew's State [now the Landmark] in 1945," Joe Detor explained. Before coming to the Palace, he was in the projection booth at some of the other, lost neighborhood shows: the Globe, Rivoli, Novelty, Acme and Cameo. He and Pat look forward to the installation of a new "platter" projection system at the Palace, bringing their house up to speed with the many multiplexes roundabout.

Still, the plexes—which some folks compare to watching a movie in a funeral parlor—never will own the charm of the Palace nor the presence of its proprietor, a senior citizen who vows she'll never retire as Syracuse's "Queen of the Neighborhood Silver Screens." Frances will squirm at that; she's stoically "low profile," in her own words, a professional woman admired by and a bit intimidating to those who know her.

Of the thousands of reels that have unwound in that little room upstairs with the blinding streams of light, she admits to admiring *Gone With the Wind*, but "most of the time I read."

Frances lets us in for $3.50—"Isn't that amazing?" she asks—and sells popcorn for a buck, but don't talk during the show or put your feet on the seat ahead or the boss will be there with a flashlight, threatening to call the

cops. She says the Palace will continue in the family in the next century because her nephew Michael Heagerty is set to step in. He's the guy who brought us Styleen's and helped his brother and sister-in-law, Patrick and Karyn, found Pastabilities.

Freda Heagerty thinks she sees Alfred DiBella's genes throbbing through her son, Michael, his grandson. "They both have lots of ideas, like to try new things," she said. Michael remodeled the Palace after "Aunt Fran's" death. It continues as an active theatre and event center.

Originally published in 1999.

HE PLAYS BASS

When Michael Casale was born at St. Joseph's Hospital in November 1949, doctors told his parents, Sanna and Elio, that he'd probably not live more than a few days. That grim prospect had special meaning to the Casales. Two years before, they had lost their first child to the same condition: spina bifida. Lucy Casale died at six months.

Recently, about one hundred guests toasted Mike Casale at his fiftieth birthday party at Jagger's Restaurant, north of Liverpool. Mike observed the occasion by jamming with some of his musician pals. "I don't play golf. I don't fish. I don't hunt. I play bass," Mike explains.

Mike is four feet, three inches tall and walks with a cane. He's had twenty-four surgeries in fifty years, including a spinal fusion, urinary bypass and amputation of his left foot. He's a husband, father, more than twenty-five years a professional musician and a marketing assistant at Gaylord Brothers library supplies. "He's been an inspiration and hero to many people," said his wife, Peg. Not to forget a surprise to those medical experts who saw spina bifida as a death sentence fifty years ago, or as life in a wheelchair, as it is for many who are disabled by the condition in which the spinal cord fails to close completely in the womb.

Here's Mike's take on survival: "They expected me to live three days. I really feel by the grace of God I'm here." And, he adds quickly, "because of my parents, who had the guts to raise me. They were told to leave me there. They could have backed away; they didn't."

Mike felt he was only as different as the way people treated him: "I wanted a wife, and a dog and white house with a picket fence just like anyone else." Mike and I talked at his kitchen table in Liverpool the other day as a chorus of sparrows made music in his yard, and Mike uncoiled his own history, which has plenty to do with music, too. When his wife asked him what he'd like to do to mark fifty years with us, he didn't pause. "I told her I wanted to get together with my family and friends and the guys I played music with over the years."

His life as a musician started the way it did for lots of us who never played a note after the age of twelve: piano lessons at the command of his parents. "Piano lessons are about the classics," Mike says, "and I wanted to play piano in Elvis Presley's band. I was not an active kid. I went to school in Fayetteville by telephone from the third to the seventh grade, so I spent a lot of time listening to music on the local radio stations. I've always liked music, but I wasn't that good at the piano. My sister, Mary Lou, always played better. I was a pounder."

Then he met a neighbor his own age in the Brookside neighborhood of Fayetteville, where his father built many of the homes. In the late '50s, Mike and Bob Purdy rode the bus to school six miles, and Bob, who played electric bass, used one of his pal's crutches to teach him the fingering. "I was totally blown away by the bass," Mike says. "In 1967, my parents got me my first."

He says he learned to play from his friend and "woodshedding" alone with his record player. In the summer of 1969, on his way to study at Onondaga Community College, he got together with another neighbor, Gary Sprague, and formed a duo that would become Neighborhood Friends and continue, off and on, until Gary left the area in 1987.

Before both of them married, Mike and Gary toured the East Coast with Friends, often playing the Holiday Inn lounge circuit. They also played Syracuse-area Ground Rounds and local clubs. After Gary left Syracuse, Mike started a classic rock band he called Rocking Horse. He took a hiatus in 1990, sat in with an oldies group and then last year joined Bobby Green's six-piece A Cut Above.

Another piece of Mike's life, from day one, is the challenge of his disability and its continuing demands on his body. When he talks about his music, his jobs, his education, the line is woven with timeouts for treatments and surgery, all the way back to ten months old, when surgeons fused his spine so he could stand and eventually learn to navigate on crutches. "My parents never let me say, 'I can't,'" Mike recalls.

He gives credit to the late Dr. Mark Harwood, an orthopedic surgeon, for making the repairs that provided him with the physical ability to literally rise

above his condition. Mike also credits his maker with another sort of strength. The Casales joined the small Worldwide Church of God congregation in Liverpool about ten years ago.

"I wasn't comfortable with what I was," Mike explains. "My wife got interested in the church in 1986. I was searching for something, so I started learning about worship and my relationship with God. I always knew God was there, but I never picked up the phone."

Originally published in 1999.

THE COACH

Roy Simmons Jr. sits at his kitchen table on Woodchuck Hill and lets the sun play games with his hair, which is gray and wispy. It seems as if his life is spread in front of us as we talk about Roy's retirement from college athletics last year. But he is not retired from that special lane of traffic he sometimes drives by himself. We're talking about art and books, two subjects the man heads into with the same passion he used to give lacrosse.

We're looking at a rare book of Picasso lithographs signed by the artist, a book about American Indian lacrosse, one of Roy's collages and a program for the 1928 Syracuse University–Columbia football game, with a picture of a handsome student captain named Roy Simmons Sr. on the cover. I don't know if my host makes a connection. I do.

"I was on top; I'd done everything," Roy said of his decision to leave his alma mater, Syracuse University, at the end of his twenty-eighth season as head coach of lacrosse, a sport that made him an all-American as a college player. "It was time to get out and smell the roses. Enjoy life. Spend more time with my wife and my studio." Roy says that the way he says lots of things, as if he means it.

Nancy Simmons is retired, too, after nineteen years teaching physical education in the Jamesville-DeWitt school district. They share the old farmhouse that they bought condemned and without heat or water thirty years ago. It's where they raised three kids who've fled the nest and dozens more young men they adopted for the four years the men played for "the Coach." Roy has had a yen for art "since my mother dragged me to museums

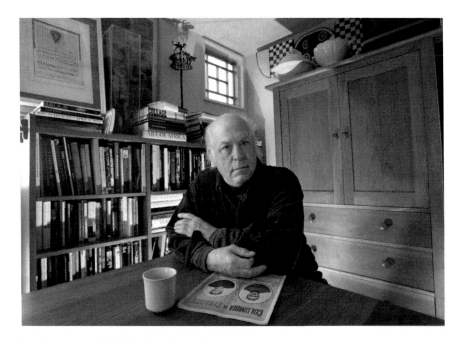

Roy Simmons with his books and art at home.

when I was a kid." He managed to be serious about being an artist when he coached. Now he can be serious without having a Saturday game plan in his head. Saturday games were big pieces of his life until two years ago. He still goes, but as a well-informed spectator sentenced to keep his mouth shut.

Sports came to Roy the day he was born. He was "Roy's Boy," the coach's kid, son of Roy Sr., "Simmy," the first of the Simmons legends to come to life in our town. Simmy was the street boxer from Chicago who retired from SU after forty-five years of coaching lacrosse, football and boxing. Roy Sr. was also president of the common council and one of the heroes of Roy Jr., who spent forty years in various coaching jobs at the university and a lifetime being with Dad.

As a teen, he helped Simmy in the corners during boxing meets. As an adult, he turned a chicken coop out back into a retirement house for his father. Sadly, Simmy died before it was finished. His son made it his studio after Senior's death in 1994 at ninety-three. Roy tried to please his father by trying out for his SU boxing team. He just couldn't cut it. Instead, he channeled his energy into his first love, lacrosse, and finding the right academic program.

Roy said his first major, physical education, was pretty much the only option for a coach's son.

Oren Lyons played lacrosse with Roy (and Jim Brown) in the 1950s. This future all-American, and Iroquois leader, was an art major. So was his pal Jimmy Ridlon, who also played football. "They came into the locker room with their art portfolios; I was fascinated," Roy recalls. He was "blown away" at seeing the works of famous sculptor Ivan Mestrovic, then an SU teacher, which the university had on storage display in old Archbold Gym.

It cost him an extra year in school, but Roy switched his major to fine arts "because I didn't see myself spending the rest of my life with a whistle around my neck." He worked and studied at Mestrovic's studio in an old carriage house on Marshall Street. Roy graduated, was hired on as an assistant lacrosse coach and struggled to make a living "with kids and a mortgage." He opened, and closed, two frame shops, where he boxed and glassed other people's art, and experimented with his own, especially his big interest—sculptured boxes.

He also apprenticed with another hero, the late artist Paul O'Connell. Paul and his wife, Ellie, a painter, made a living teaching and framing in an abandoned church in Fayetteville. "Paul was a great influence on me," Roy says.

Roy's also always been an avid reader. His former teammate Jim Ridlon, an SU art teacher and fellow artist, calls his pal "my go-to guy for art. I knew he read everything."

True. The man is encyclopedic about art, books and the marketplace. Art and literature fill the Simmons farmhouse and studio. He's an adventurous collector of books, a supporter of the SU library as donor and board member of Library Associates and a man for whom acquiring "things" is a way of life.

Roy and Jim Ridlon recently did another Two from the Team exhibit, this one at SU's Lubin House in New York City, where Ridlon paintings and Simmons collage boxes were shown. Roy's work consisted of "flotsam and jetsam" collected in West Africa and given new life in different environments.

His studio has file drawers stuffed with pieces of paper that he uses as palettes for collages. A recent creation has a sheet of Italian music on parchment and a metal heart. In one drawer sits a collection of the lacrosse posters he commissioned during his time as coach and a few of the famous Simmons watermelon posters he designed years ago "as a joke for a friend." They're collectors' items. Roy says he's comfortable with his new life as artist-collector. He once taught fine art at SU but had to step back because of lacrosse. The dean tells him he's on sabbatical and may come back to a classroom when it feels right. "I'm thinking about it," Roy says.

Originally published in 1999.

JILL

Jill Lyn Euto's favorite color was pink. If her mother has her way, this town is going to be bathed in it. Jill was stabbed to death in her 600 James Street apartment January 28, Super Bowl Sunday. She was eighteen. The killer is still out there.

Joanne Browning's child was taken from her. She's stricken and angry. The only thing she knows to do is mourn Jill and keep us focused on finding her killer. Joanne is spreading pink around the city: pink fliers asking for help in solving the brutal crime. Pink ribbons to help us keep Jill on our minds. "I know somebody had to have seen something," Jill's mom said in her living room in Lyncourt. "This is my way. I can't be out on the streets. I have to do something for Jill. I promised her I won't stop until her killer is found. I'll be putting those posters out until I die; I'll never stop. As long as it takes."

Candles burn in the little house, next to pictures of Jill from Christmas. They are the same pictures as are on the fliers.

Joanne wears a pink ribbon. So does Jenna, her sister. And Hooch, Jill's Boston terrier. There are more ribbons on the hoods of the cars parked outside. Likewise on the tree in the yard, where Joanne put a vigil light and a pink cross. Joanne had two hundred copies of the poster printed, at first. She and Jenna and other family members have spent the last week hanging them in stores and on utility poles, particularly in the lower James Street neighborhood where Jill lived. Lyncourt fire volunteers helped.

The James apartment house is at James and North McBride. Jill lived on the sixth floor. She had lived there about a year. This was her second try living on her own; she did once before, then came back home for a while. "She was doing well," Joanne said. "She felt comfortable there." Jill shared her apartment with her dog and worked at Aéropostale clothing store in ShoppingTown. Before that, she got work at stores in Carousel Center, sometimes two jobs at a time. She didn't drive; she rode the bus.

The James has a buzz-in lock system for the front door. "People can't believe this happened in a secure building," Joanne said. "That's a joke; anybody could get into that building. I guess they're making damn well sure it's secure now." Police guess that Jill might have known her killer. "She must have been caught off guard," according to her mother. "She

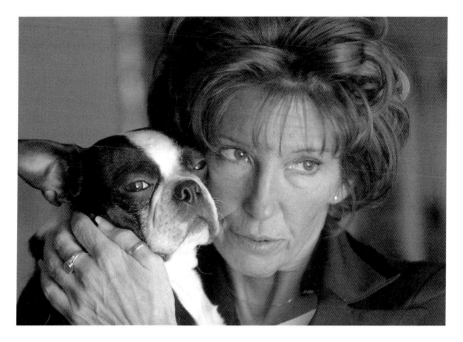

Joanne Browning with Hooch, the dog that belonged to her murdered daughter, Jill.

wouldn't hurt a flea. She always was well-liked. She helped older people and loved kids. She didn't want anything more than to be married and have children."

Joanne and Jill talked for the last time on the phone just before noon the day she died. Her mother remembers Jill being "her usual, bubbly self." They made a date for Jill to come to her mother's that night for a Super Bowl party with other family members. She had worked Saturday and was due back Monday.

Jill should have arrived at Joanne's about six o'clock that evening. Her mother tried to call her again about three o'clock; no answer. She might have gone out. On a quick trip to Carousel? Or to take Hooch for a walk? When Jill didn't show for the party, Joanne was concerned but not worried. "She usually never missed coming when she said she would. I figured something came up." Worry and then fear arrived the next morning when Joanne said she tried "calling and calling and calling" her daughter, and the "phone kept ringing and ringing and ringing." She called Aéropostale. No, they hadn't seen Jill, either. Their calls were unanswered, too.

"It just didn't feel right. Jenna and I got in the car and flew over there," Joanne said, her voice cracking. "I had to find her." And then, tears streaming down her cheeks, she said, "I want this person so bad. I'll hunt them down."

Joanne and city police guess that Jill—who was blond and petite—may have left her apartment between 1:00 and 9:00 p.m. "Please—if anyone saw Jill Lyn Jan. 28, 2001," Joanne wrote on the poster.

Captain Dick Walsh of the city police department's Criminal Investigation Division amplified on the plea for help. Detectives would like to hear from anyone who might have been in the 600 block of James Street that afternoon.

"Even if they didn't see anything they think is significant," the commander explained. "It might be significant."

Joanne calls the detectives every day. We're working this, we're working this real hard, especially when it comes to confirming alibis, they say. She says she believes they are. If only.

Originally published in 2001. Joanne Browning died in an accidental fall in 2007. Her daughter's murder remains an unsolved case.

CONGRESS PARK

I'm sitting with the mayor of Congress Avenue and the captain of this block of the West Side at a rickety picnic table on the empty lot where the Abrahams' home used to sit. The house burned down about ten years ago. Debris was cleared, and grass started to grow. So did trash, human and otherwise; somehow vacant lots turn into community garbage bins. But not for long. Not in this 100 block of a two-block street off Grace Street.

The mayor and the captain stepped across their street and claimed the lot as the neighborhood's. Now it's a little community park, maybe the only one of its kind in the city. Soon it will look even better than it does this week.

"We've got plans," said Alice Smothers, one of the neighbors who stepped in. Her helper is her fiancé, John "Bubba" Cannon, a big man with a huge reputation in these parts. John smiles: "They call me the Mayor of Congress Avenue." To the kids, he's "Uncle Bubba." Both titles seem well earned.

John and Alice drew a line around their park, literally and mentally—don't mess with this. This tough love approach seems to be working. "The kids really respect this park," John explained. "We tell people, 'You respect me, I'll respect you.'" The couple bought the house across from the lot twenty

years ago. John is retired; Alice works as a liaison between Porter School and parents. She's also vice-president of Home Headquarters, the agency that helps people find places to live. Home Headquarters, among other projects, has Weed and Seed Community Partnership and is organizing neighborhood block associations. Congress Avenue's is one of two set up so far, and Alice is its captain.

"She does what her heart tells her to do," according to Nancy Kronen, coordinator of Weed and Seed, which opened a West Side partnership last year.

"I saw that vacant lot every time I looked out the window," Alice said at the picnic table. "We decided to use it to do something for the retired people and kids who live around here and don't have yards. We're trying to get the family thing back."

Kronen of Weed and Seed, which helps clear city areas of drugs and drug dealers, said the work of Alice and John is a textbook example of what her agency is about: "It's about a neighborhood setting its own standards." Alice calls them "neighborhood rules." She and John take it on themselves to greet new residents and share: "no loud music, no loud TVs, no hanging on the corners, no drugs or alcohol in the park; we hope you'll plant some flowers and join us in our little lot for a party now and again."

That's how this piece of turf got to shine in a part of the city that some experts say is one of our worst for crime and poverty. Over the last few years, it's been the scene of a wedding of two neighbors, birthday parties and celebrations of report card day. "Heck, we roasted half a pig on Father's Day," John reported.

Just then five neighbors sit at a table in a shady corner of the park and begin playing dominoes. They also gather for checkers, card games and Uncle Bubba's famed cookouts. "Oh, I started it. I did it all," he boasted, adding that most of the time he and Alice buy the food they serve. They also pick up surplus bread and baked goods and hand them out on the lot. The 100 block of Congress provides food for the soul, too. The couple and their neighbors cooperate with police and city agencies to hold back crime and other antisocial behavior.

Amer Abraham joins us. This lot held his grandfather Abe's place when he moved to Syracuse from Palestine and opened Big A Market across the way on Merriman. His dad, city cop Mark Abraham, had the store; now Amer and his brothers run it. Neighbors call Big A "the police store." Bad guys are not welcome, including dudes who ask Amer to sell them a "stem" crack pipe or a "nickel bag" of drugs. "We drew a line," Amer explains. "I'd rather not have that kind of money."

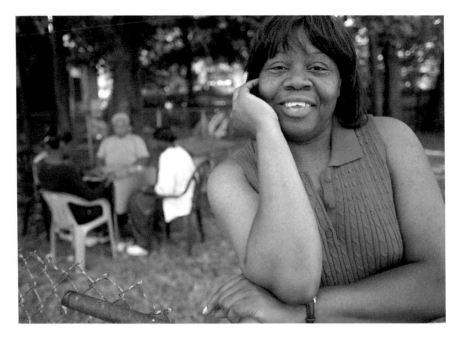

Alice Smothers in her neighborhood, Congress Park.

Amer and other neighbors have been pestering for months about conditions in the house at 200 Kellogg Street, next to the park, and at 107 Grace Street. "We're trying to clean up and get landlords to take care of their properties, but the city needs to do its part," he says. Meanwhile, the neighbors do theirs.

My hosts point out Sarah Knight's house at the corner. "Miss Sarah," as she's known, is putting new siding on the place. It looks great. The neighborhood has more renters than it did when Alice bought her stake twenty years ago. Back then, most places were occupied by their owners, and the venerable St. Paul's Lutheran Church—a German-speaking congregation that came in 1928—was the focal point.

Last year, Alice and others from Home Headquarters went to New York City and toured Harlem. She saw what neighbors did there to reclaim their turf; she started sketching plans on the bus on the way home. A friend who is a landscape architect drew a plan for a park for her. Alice unfolds it on the table. Let's see: they'd have a gazebo, a fence to be locked at night (and no lights, to discourage midnight loitering), a sandbox, play equipment, a kiosk, trees, a garden in the middle and more. Neighbors are working with Weed and Seed to find grants and donations to complete what Alice and John started. They'd like to hear from helpers.

One thing Alice is sure of is that this will be a place of comfort and safety, not crime. She and her neighbors don't like what they see happening in nearby Grace Park, or what they worry will happen when the new park on Shonnard Street—the old baking company lot—is finished.

Ted Grummons grew up on Merriman. He's had his auto repair shop at the corner across from the church for thirty-five years. He praises what Alice and John have accomplished in the vacant lot and worries that druggies will do on Shonnard Street what they did at Grace Park. "There's no kids playing there," Ted says. "The drug dealers sit in the swings waiting for people to drive up. They drove the kids away."

Originally published in 2001.

THE COBBLER

Say it isn't so. It is, according to Sal Phillips. Sal has decided to call it a day as a cobbler in Syracuse. He's closing the shop that's been a part of city history, and Eastwood tradition, since 1922. "I've been evicted," Sal explains. "I'm seventy-three years old. Why start all over again? I'll slowly fade away. I've kept on longer than I should have because of the long tradition."

His dad, Angelo, opened a cobbler shop on the main drag in Eastwood in 1922, when this city neighborhood was still its own village. Sal took over in 1965 and eventually relocated to Shop City, where he's had four locations. "It used to be a good business," he says. That was when shoes were made of leather, not fabric and plastic. We wore real shoes, not sneakers. Yes, we treasured those leather homes for our feet, some of them actually made by experts such as Sal and his dad. Now, we "use it up, get a new one," he says. Sal calls cobblers an endangered species. He's right, measured by the businesses listed in the Yellow Pages. Seven that say they repair shoes.

In the 1920s, when Angelo Phillips began after putting down the trumpet he used to play in circus bands, that directory showed 130 shoe repairers and 17 shoe shiners. In 1948, as Sal studied economics at Le Moyne College, he and his father helped start the Syracuse Shoe Repair Association, with one hundred member shops. The group folded years ago. "Now I'm the oldest," Sal observes. "There was a time I was the youngest."

Now there will be six shops in the county, two of them in the Tirinato family. Ted Tirinato and his brother, Dominick, carry on the business started by their father, Anthony, in 1953. Ted has the original shop on North State Street, and Dominick's is in DeWitt on Genesee Street. Ted says he agrees with Sal about being an endangered species of craftsmen. "You can count them on one hand," he says. Ted's State Street store, Leather Haven, has evolved from his father's cobbler shop to a general store of leather goods, some homemade, and repairs on luggage, zippers and canvas. "We even fix the stretchers for Rural/Metro," according to this cobbler. The store looks out on Nettleton Commons, the apartment complex that used to be a premier Syracuse business, Nettleton Shoes. The Nettletons were high-end and long lasting. "I still get thirty-, forty-year-old Nettleton shoes to rebuild," Ted explains.

Sal Phillips thinks the profession has changed so much that "in another ten years, there will be no shoe repair business."

He expects his own to be closed soon. Most of those venerable machines will be given to a jobber downstate who rebuilds them for sale overseas. Sal was told by the landlord, a company in Connecticut, that a clothier wants to rent all of the Shop City space once occupied by Chappell's. His Phillips Cobbler and Leather Specialty Shop rented one corner.

"They offered me another space across the way, but I said no," Sal explains. "I've got to do it. Still, I want to thank all my customers who've been so loyal to us all these years." Sal plans to continue fronting one of the bands that he's had since he was a student at Eastwood High School. The Rhythm-Airs play every week at Fireside Inn in Baldwinsville. He also wants to spend more time in his garden: "I'm going to retire and smell the roses."

Originally published in 2002.

ONE LAST ROSE

This is a story about the old neighborhood, sweet memories and beautiful moments of discovery. I'll let Esther Strutz Bettinger tell it.

History Lessons

When I was a little girl about 9 or 10 years old, I used to roller-skate from my home in Lyncourt up Court Street as far as Johnson's grocery store, on the corner of Court and Loma Avenue. Then, I never failed to go around the corner on Loma and visit Mulhauser Florist. I would just stand and look and look in the window at the many beautiful and colorful flowers, and think someday I would plant all kinds of flowers in my own yard.

Then, much to my surprise, one day while I was looking in the window, a man came to the door and asked me if I'd like to come in and see the flowers. There was usually a woman and himself inside. I said, "I can't buy any—I don't have any money," and he said, "That's all right, you can see them better inside." So I went in, skates and all. The lady had me watch them work, and I touched and smelled each and every flower, while she told me the names of them.

When I left, the man gave me one flower that he had wrapped in green tissue paper. I don't recall the name of the flower, but I left and skated home and gave it to my mother, as she also liked flowers but rarely received any.

Many years passed. I grew up, married and had four children—one son and three daughters. When my husband and I were married 56 years, I became a widow. I lived on in our home for seven years, and then I decided to buy a home in a senior park [in Central Square]. *A few days after I moved in, in February 2000, I heard a knock on my door. It was a woman with a beautiful flower arrangement for me from a daughter and son-in-law. I noticed the card had "Joseph Mulhauser Flowers" on it, and I asked if that was any way related to the Loma Avenue Mulhauser Florist.*

She said, "Yes, that was my grandmother and grandfather." The business had been handed down in the family through many years and is still operating in the same location. I proceeded to tell her how as a child I had always looked in the window many, many times, and how one day, I was invited in. A look of wonder came over her face. She said, "My God! I've found my grandfather's little girl."

Then she told me that her grandfather told the story over and over at any family get-together, about the little girl who always looked in the window, and how he asked her in to see them better. The deliverywoman stayed a few minutes, and as she was leaving, she said, "Wait till I tell my story at the next family gathering."

The deliverywoman mentioned by Esther is Debbie Mulhauser Trzaska, who runs Joseph Mulhauser Flowers on Main Street in Central Square. Her grandparents were Anna and Leonard Mulhauser, founders of the florist shop Esther visited as a girl. The Mulhausers remain where they

started, in that store off Court Street, doing business more than ninety years through three generations. The proprietor is Anna and Leonard's daughter, Ruth Egle.

Debbie tells me that the Mulhausers got started as florists because they had a bountiful garden at their home on Loma Avenue. "My grandfather started picking flowers from the garden and selling them door to door," she explains. "Then they started selling flowers in Assumption Cemetery," which is close by. Eventually, according to Debbie, flowers and plants became a "family affair," with the Mulhausers' four children and their wives and children working the trade.

Her father, Joe Mulhauser, and his brother, Norman, expanded into wholesale growing. They bought the greenhouses run by the E.W. Edwards department store just south of the city line in Nedrow, where the modern Green Hills Plaza sits. The family—with an assist from Grandpa Leonard—had the greenhouses until they burned in 1969.

"They started right on Salina Street and ran all the way back to the creek," according to Joe's widow, Anne, who says she used to help out in the business on busy occasions such as Easter, Mother's Day and Memorial Day. Anne had her own shop in LaFayette for about fifteen years. Her daughter, Debbie, used to go to the store and, true to her genes, "play with the flowers. She thought I had a talent."

The family affair continues. Five years ago, with the help of her dad, who died in 1999, Debbie opened her own place in Central Square. "Now I know this is where God wanted me to be," she says. The business is named for Dad. Debbie struggles to describe how thrilled she was meeting Esther Bettinger and realizing she was the "little girl" of the family story. "This lady touched my life in ways you wouldn't believe," she says.

Jan Gerle and her sister, Karen Campbell, sent me their mother's story last month. They mentioned that Esther grew up in a family of ten children and that she worked at Wilson's Leading Jewelers many years, as well as at DeWitt Car Wash as bookkeeper. This past Easter, when their mother was in Florida, Karen arranged for a floral arrangement to be delivered to her. "It was accompanied by a single pink rose with the note, 'Best Wishes from the Mulhauser family,'" Jan explains. "She was touched."

Esther was ill, in the care of hospice, when I first read her story. She died June 8 at the age of eighty-one.

Originally published in 2002.

PART II
HOT DOGS AND SAUSAGES

MCCARTHY'S ISLAND

Bob Wall can talk a lot about McCarthy's Island, a buried landmark of Syracuse. He talks about his mother's family farm on the island, spreading across twenty acres in the city's Valley neighborhood, between Atlantic Avenue and West Newell Street. About watching the uncles cut hay. About the big farmhouse in the middle of the island, with its heating stoves, huge square piano in the parlor and five or six bedrooms. About the barns, the horses, the muddy old millrace that separated the farm from the rest of the Valley. About the outhouse, the water pump out back, the home without electric power, ever. About "Uncle Michael," the last McCarthy on the place, a bachelor who lived alone in that old house and got to be "an Elmwood character." About learning to drive in the pastures. About having an inside view of Ringling Brothers circus when it came to the island for three days in the 1930s. The circus folk used to unload from trains at the Geddes Street yards then move the show in trailers to the island, which the family rented to them for the occasion.

"The elephants walked, of course," Bob says.

Bob's eighty, retired and blessed with memories of the McCarthys. My friend wrote the *Herald-Journal* ski column for twenty-seven years. He's old enough to have known his great-grandmother, Bridget Ford McCarthy, wife

of Michael, who bought the island in 1873. Michael's descendants sold it to a developer in the late 1940s. Ford Avenue was a block long, off Valley Drive, back then. It ended in a wooden bridge leading to the island. The street took its name from Bridget's family, who were Irish immigrants and Salina salt boilers.

McCarthy's stopped being an island when the family left. The meager millrace that looped west out of Onondaga Creek made it an island. It had been cut for Amidon's mill in the early nineteenth century. That was filled by a developer who bought the land. Then, the developer built an apartment complex of fifty-seven buildings called Shady Willow Estates.

Shady Willow went out of business a few years ago. The city took the property for back taxes and this year sold fourteen acres to Home Headquarters, the nonprofit housing agency that wants to renew the old island as the site of forty to forty-three single-family "trade-up" homes of three or four bedrooms. Demolition of the 228 apartments started the first week in June and has been delayed by a dispute between the contractor and state officials about asbestos removal.

As memories and dust stir, so does conversation about the future of this interesting piece of property. Since Shady Willow is neighbor to Onondaga Creek, and the creek is the object of new interest and studies, this large lot in a flood plain and wetland is brought into the discussions. Not only is the creek, as it flows between the Onondaga Nation and Onondaga Lake, a part of the lake cleanup project, but it's also being looked at by the Army Corps of Engineers and researchers at Atlantic States Legal Foundation and the State University College of Environmental Science and Forestry.

"Everybody should be concerned with this land," Sam Sage of Atlantic States says of the property. "This is an opportunity to look at the options."

The options, by Sam's measure, ought to include making lost McCarthy's Island part of a creek restoration project that might bring back some of Onondaga's historic "meandering" through this part of the city, along with its value as a place to fish, garden, walk and recreate. Atlantic States recently cooperated with neighborhood activist Kathy Stribley and her students at ESF on a study for the city's Economic Development Department that could be a preliminary to a full-blown plan for creek restoration.

The study combined research and design suggestions by the students with a NASA satellite mapping that shows how the creek used to snake through the Valley on its way to the lake. Sam Sage sees this material as the basis for a community discussion of future use of land along the creek, including McCarthy's Island. That's the reason the environmentalist, who is famed for his activism in lake cleanup, wants the Shady Willow property to be "land-

banked" as soon as demolition is done, rather than starting immediately on construction, as suggested by Home Headquarters.

As Syracuse grew and came into the twentieth century, development had its way with the creek. The Valley, once its own community, merged into the city in 1927. That was about the time that work began to reconstruct Onondaga Creek for flood control and safety. Between the 1920s and 1950s, the channel was straightened, widened, deepened and lined with stone blocks in some sections. The millrace meander was one of the last to go. The project included the new federal flood dam on the creek at the Onondaga Nation, a public work that modern planners say was overkill and incomplete.

Sam Sage says the Army Corps of Engineers has ideas about creek restoration. He sees the preliminary study as a step to be followed by research by the corps into the creek watershed within the city. Sam talks about the creek as a community asset, especially in terms of economic development south of downtown. He mentions successful "riverway" projects elsewhere, including San Antonio, Denver and Boulder, Colorado.

Kerry Quaglia, executive director of Home Headquarters, told me last week that he thinks demolition at Shady Willow can begin again within a week or so. The work has a $1 million grant from the federal Neighborhood Initiative program. Yes, he has talked with Sam Sage about some of his ideas, but he's "not sure if our plans and theirs complement each other." Preliminary designs for the site, with input of neighbors in the North Valley Oasis Initiative, include links to a proposed creek walk and three acres of "passive park" land.

A personal footnote: Mrs. Michael McCarthy—Bridget—was my grandmother Margaret Hickey's kin. "Maggie" came from Ireland to live with her uncle Patrick Ford on the city's North Side. We believe Bridget was the daughter of Patrick's brother Peter. My mother mentioned "Fords in the Valley" who were her relatives.

Originally published in 2002.

DON AND CASSIE

Don Waful sits in his warm living room off Meadowbrook Drive, a few snowflakes dancing outside, the sun beginning to brighten, his leg over the arm of the easy chair. CD music surrounds us. "I'll be right back…I'll be home before you know I'm away," the actors sing, their voices rising. Don's got a hand on his chin and his thoughts years and miles away.

A duet pledges love. Don and Cassie may part, but they'll come together again. "Let the future come," they sing on the way to war. The voices on the disk belong to actors Becky Watson and Edward Staudenmayer. The story, the emotions, belong to Don and Cassie Waful of Syracuse. Don's a retired insurance agent who plays trombone and has been president of the board of our baseball team for thirty years. He was a tank officer in World War II—a young man from the Shotwell Park neighborhood who met a beautiful army nurse from Boston, got engaged, was captured by the Germans, lived three years in POW camps, lost contact with Cassie and then found her. They married at the end of the war in the office of a small-town French mayor who couldn't speak English. They were man and wife for fifty-three years. Cassie Waful died in 1998 at the age of eighty. Don survives at nearly eighty-six, a man of vigor, remarried, still playing the trombone, still loving the game of baseball.

We're hearing the Wafuls' life put to song, inspired by the real thing. That CD captures words and music from a play called *I'll Be Seeing You.*

Don learned to play the trombone at North High School. While he waited to be shipped to the war, Don sat in with an army swing band. One night, they performed at a dance for the Fifth General Hospital Company, "an outfit of Harvard doctors and Boston nurses." One of the Boston nurses—Olga Casciolini, nicknamed "Cassie"—caught Don's eye, and vice versa. They danced, held hands, "and I proposed on the third date," Don explains. "I courted Cassie sixty days before we went off to war. She went to a field hospital in Europe, I went to North Africa."

Cassie nursed the wounded of D-day and the Battle of the Bulge. Her fiancé was captured by the Germans and turned over to their Italian allies, who shipped the American and British prisoners to a camp in Italy. The Italians were amazingly easygoing captors. Don had his trombone and received letters from Cassie, although there might be six months between hearing his name at mail call. In September 1943, Italy dropped out of the

war, "most of the Italians at the camp went home" and Don and his pals found themselves on a train to Poland.

The prisoners spent fifteen months in Poland before the Germans marched them into Germany during January 1945. Once they got to the new prison, the mail stopped. "Cassie knew I was in Europe, and I knew she was in Europe, but that's all," Don said.

Then one Sunday in April, the Germans left the camp as the Russians took over. The new army wanted the prisoners to stay, but security was lax enough "that men started walking away." Don and his buddy Bob Savage did that one day, connected to the Americans "and then I started looking for Cassie." With "a lot of luck" and the American Red Cross, he tracked down the Fifth Army Hospital and his beloved nurse. First, they spoke on the phone then reunited at a POW station in France. The war was over.

"Two days later, we were married," Don's saying, his eyes still twinkling. The Army Signal Corps served as the Wafuls' wedding photographers. An officer threw them "a hell of a wedding party," champagne and the works.

Don came back to Syracuse first, then Cassie a few weeks later. They set up housekeeping, found jobs and raised two sons, Peter and Don. Over the years, they shared their story with friends. One summer in 1998, they went to Cape Cod for a vacation. At a bed-and-breakfast, they sat with a couple from New York City, Diane Tauser and her husband. "We started to talk," Don recalls, "and eventually we told them our story."

At the end of it, their new friend, Diane, spoke up: "I'm going to write a musical play about that." She did, although two fast words can't convey—according to Don—the many peaks and valleys of this creative process. Diane wrote not only the play's book, but the words and music as well.

Cassie died early on in the creation, but the writer spoke often with Don, sometimes visiting him in Syracuse, sometimes talking on the phone or passing bits of script and comments through the mail. "It's been a long three and a half years," Don says.

I'll Be Seeing You has been playing weekends in a small theatre of the new Kimmel Center for the Performing Arts in central Philadelphia. Don and Ginny, his new bride of eighteen months, were there for opening night and the night after. They were thrilled, of course. The cast got a standing ovation after the premiere, and eventually Don was "pushed" on stage to take a bow. The actors who play Cassie and Don wore Cassie and Don's old uniforms, pulled out of a closet in Syracuse.

I asked Don how he feels, seeing his life on the stage. He says he learned to put the real and the imagined in separate boxes. "I've been able to

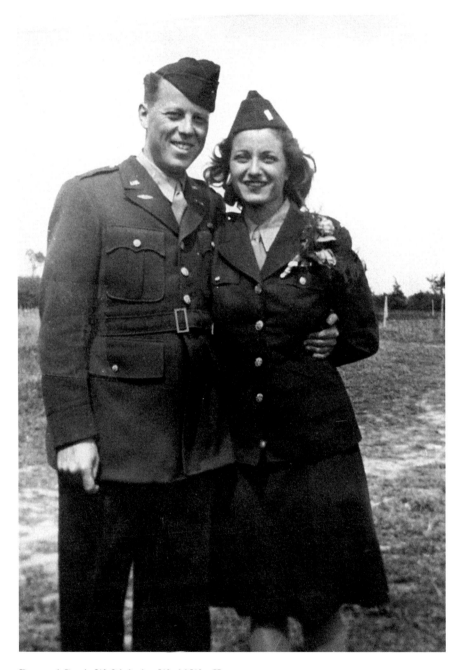

Don and Cassie Waful during World War II.

compartmentalize the show, and the emotions of the actual events," he explains. "Otherwise, I'd be a wreck."

Exhilarating as this is, the experience has downsides. One was the review of the *Philadelphia Inquirer* theatre critic, who, Don says, unlike the audiences, wasn't impressed with the play. The other is the fact that it didn't premiere in Syracuse, where Cassie and Don lived. "I would dearly love to bring it to Syracuse," he says, explaining the rejections he and the writer got from Syracuse Stage, the Syracuse University drama department and Salt City Playhouse.

That's got to happen. Still, when he thinks about it, Don's a little amazed that *I'll Be Seeing You* happened at all: "I think the Lord had this story in his mind."

Originally published in 2002.

ARTIFICE

Three years ago last month, I talked with Catherine Gottlieb about Armory Square, where she opened an art gallery called Artifice in 1992. Catherine was a World War II refugee, a model, actress, skier, teacher and patron of artists. She arrived in our town in 1971. In the little downtown neighborhood south of West Fayette Street, she found heaven among the earthy leftovers of an abandoned packinghouse district.

Our talk that day in 1999 had to do with Catherine and her Walton Street neighbor—Ellen "Petey" Hildenbrand of Hendricks Photo Supply—being presented with Abraham Walton Awards from the Armory Square Association. Catherine's honor was for "visionary persistence." There was no doubting her persistence or vision.

"I want to die here," she said to me. "Syracuse is a delightful place to live, and this neighborhood is unique."

Catherine was one of a kind, too. She died this week at sixty-four.

We met back when she took my friend, Bill LaMirande, under her long, graceful wings. Bill lived in Skunk City and created wonderful paintings about his hometown after he retired as a security guard. The sophisticate who was born in Belgium and lived in Paris, Boston, New York, Washington

and Philadelphia and the modest artist who painted in his basement hit it off. Catherine eagerly showed and promoted Bill's work, the way she did for other artists.

Bill, who died in 1996, couldn't stop sharing his regard for "that lady downtown who says she loves my work." Catherine wasn't an artist, but she loved art and knew how to present it to us. She once told me that her colorful mix of local and regional artists at Artifice was meant to "provide customers with things they didn't know they wanted. Our loyal customers know where to go for the giggle."

Wonderful as it was, Catherine's little art shop next to the creek never got us chuckling loud enough. Artifice was a financial struggle for her from day one, with the boss working six days a week with part-time help and tons of energy. "This has been a select group of people, people who are willing to take risks," she once said of Armory Square merchants. "We have no dummies down here."

We've never supported art galleries the way we should in Syracuse. Artifice survived longer than most, but more than a year ago, Catherine closed on Walton Street and moved in with her friend, Bruce Block, at Antique Underground. When Bruce decided to fold that landmark of the

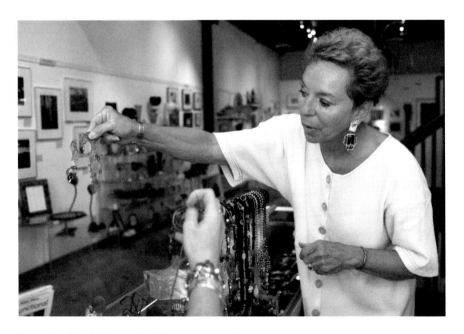

Catherine Gottlieb in Artifice Shop in Armory Square.

square in February, she went with him. By then, Catherine had taken on two more challenges: a new job as manager of the Everson Museum of Art shop, and cancer. She triumphed in the first, lost to the second.

Catherine was amazing, said Everson Director Sandy Trop at Wednesday's memorial service at the museum. She stood out as the outstanding piece of sculpture in the Sculpture Court. The truth is that Catherine stood out just about anywhere. This tall, elegant woman, dressed as stunningly as any model we'd see in Vogue, took over the room when she stepped in. "Color and light," her sister Fran said of her during the service.

Color and light that warm us still.

Originally published in 2002.

THE MARKET

It is close to noon, and Andy Russo is about done with his day at Russo's Produce at 2100 Park Street, the Central New York Regional Market. Maybe he'll head out as soon as the truck from the state of Washington arrives with a load of apples and pears that we could be eating in a day or two at my house. Andy and his kin are into the third generation at this stopover in our Central New York food chain.

The "Regional" is a local landmark, the largest farmers' market in the state in one location, on forty-seven acres of filled, marshy flats next to the south shore of Onondaga Lake. It's been there since 1938. Before that, the city ran public markets downtown, near the modern Interstate 81 Butternut Street ramp and Clinton Square. It's home to not only twenty-five commission houses, like Russo's, but also a Saturday public market, a Sunday flea market, a diner, a new commons of specialty shops and a large food warehouse, all in a neighborhood of the regional transportation center, the ballpark and Carousel Center mall.

"One of the challenges of a place like this is there are so many things going on," according to the man in the middle, Ben Vitale, the Cayuga County farmer who has been executive director of the Central New York Regional Market Authority since 1997.

Ben's office on the second floor of the commons building has big windows on the market yard. A quiet weekday morning gives him time to talk about what makes the complex purr. One thing I learned early on is that despite the market's proximity to a possible Destiny USA "footprint" across Park Street, it's business as usual on this lot.

"Right now, that's the furthest thing from our minds," Ben says. "Sure, if it does happen, it will benefit the whole neighborhood." Ben, his staff of ten and the thirteen-member authority board just finished $8.4 million in renovations, most of them paid for by the state. This includes new parking and roads and redoing some of the sheds under the watch of state preservationists.

The market authority is a nonprofit public benefit corporation (like the Thruway and dormitory authorities) under the state Department of Agriculture. It covers seven counties—Onondaga, Oswego, Cayuga, Madison, Cortland, Oneida and part of Wayne. Along with Rochester's Genesee Valley Regional Authority, it's the only one left of a statewide system of regional markets set up by the state legislature in 1938.

"We're completely self-sufficient," Ben says proudly. "We're able to subsidize the market by leasing rental spaces and the farmers' and flea market fees."

The commons, with shops on Park Street, was created with the authority's own revenues, along with the remodeling of the outside of the Market Diner, another 1938 landmark. The Marinos family paid for interior work. Renovation meant changes at the market, not all of them nifty for leasers. A few of the larger, older commission houses—including Syracuse Banana and Nesci Produce—had to relocate; they were too big for the new quarters.

Ben Vitale has no apologies for this. "Over the years, this has evolved into more of an incubator for small businesses," he explained. "Plainville Farms started in the market; so did Adirondack Furniture." Another change has a longer timeline to it: the mix of New York state, out-of-state and imported produce on the market. Local farmers still have the edge—"they're fresher," Ben says with a smile—but others have come in to join the competition.

Ben's father, also named Ben, ran a dairy farm on three hundred acres near Montezuma until he retired in 1988. His son and Ben's wife, Sharon, took over the farm but reduced their own plot to ten acres, where they raise fruits and vegetables for the retail markets in Auburn. They grow corn, soybeans and alfalfa on the rest of the farm. "Keeps my feet on the ground," says Ben, who often arrives at Park Street about the same time as the other produce dealers. Two of the original shops in the commons have closed.

Hot Dogs and Sausages

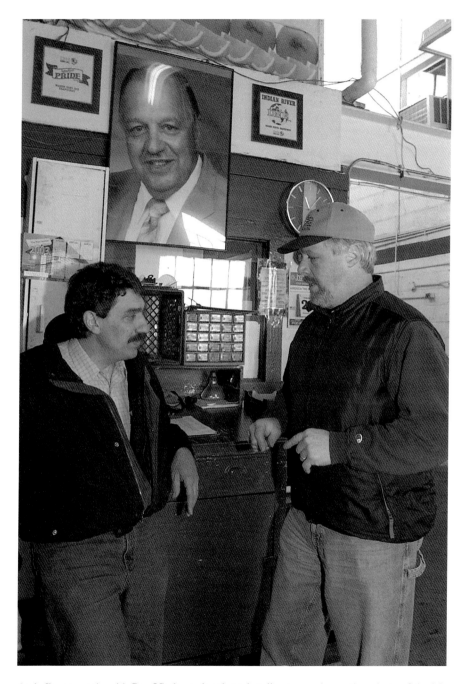

Andy Russo speaks with Ben Vitale, regional market director, underneath a photo of Andy's dad, who started his business.

Some owners recently shared their worries about the viability of the new venture with our reporters. Ben says that he isn't concerned right now: "It's a general rule that it takes a new business at least three years to catch on."

Meanwhile, as the staff puts the finishing touches on renovations, Ben and the board look to new uses for the forty-seven acres, including more parking near the transportation center with a shuttle to the sheds and a fast-food restaurant, Wendy's, which could open this summer near the Park Street entrance. "We've done some large public events here, like an Oldies Festival, and we'd like to try more," Ben says. "This could be a seven-day-a-week operation. Just like the commons, we want to try things; we don't have to bring people in. We've been here more than sixty years; we plan to be here sixty more."

That's why Ben says he doesn't see the state wanting to change the market much, considering the investment of more than $50 million hereabouts since plans were put out for the transportation center, stadium and market redo in 1988.

At Russo's, no one gazes across the street at those wispy architectural renderings of Destiny USA, either. There are fruits and vegetables to be moved. Ben Vitale and I walk back to his office across a yard that's been pruned of its snow so the trucks keep moving in and out. The wind picks at us, but the sun is shining. "It won't be long," the director says.

It won't be long before this is filled with trucks, cars and people with big grins on their faces. The sheds bloom with spring plants and the smell of greasy, fresh doughnuts is in the air. Spring is the market's prime time of year. "In the plant season, we get three hundred vendors and fifteen thousand people out here on a Saturday," Ben says.

Originally published in 2003.

HOT DOG KING

Build yourself a good hot dog, and in time you're a tradition. I'm thinking that the other day as I follow Walter A. "Rusty" Flook around the cool and squeaky-clean plant north of Carrier Circle where he stuffs and cooks hot dogs—sometimes a million a week in the dog days of summer.

We're talking about the German franks and coneys (aka Snappys) that have been part of our lives for generations. His Hofmann Sausage Company will be 125 years old next year. The Hofmann dog is out there with salt potatoes, Columbus Bakery bread and other local foods as icons of the times. We can't live without them. Which makes Rusty Flook, the great-great-grandson of the first butcher named Hofmann in our town, the Hot Dog King of Syracuse. He's earned it. The man loves to make hot dogs.

"What I love about this business is making something and then to see the look on people's faces when they eat a hot dog," Rusty explains. That would be steamed and smoked meat that's a perfect shade of pink and snaps back when we bite into it.

Hofmann is a survivor. Rusty will tell us that's because he and his ancestors kept their focus on the product and how it tastes. "We may cost a little more, but we've got the quality," according to the president of Hofmann. Frank Hofmann came to Syracuse in 1861, when we had a man in a white coat cutting meat in just about every block of the city. Today, only a few mom and pop sausage shops survive; Donze's on North Townsend Street and Liehs & Steigerwald on Grant Boulevard are two.

Then there's Hofmann, a small company that has evolved over the years from a full-service meat company to a modern, computerized plant that produces wholesale for the stores and restaurants of the region. Rusty has a year-round workforce of thirty people and a fleet of delivery trucks. He's also a fifty-fifty partner with the Dellas family in three Hot Haus restaurants. Yes, the Dellases are the Varsity Restaurant folks.

Hofmann has plans for a second warehouse and a new website—www.hofmannsausage.com. And as of this month, Hofmann is the official hot dog at the Dome. SU's athletic department just finished converting its food stands, so the dogs are grilled rather than boiled. Who wants to eat a limp, boiled hot dog, anyway?

Rusty says his father, Walter Flook, who died earlier this year, invented the "Ball Park Frank" name in the 1930s, when the family had its plant on Hiawatha Boulevard, near the Chiefs' ballpark. Those were the days the Hofmann shop included a slaughterhouse. Now, well, the plant is closely regulated—the U.S. Department of Agriculture has a field office at Hofmann—and passionately "sanitized," in Rusty's word. "I bet we're cleaner than a lot of hospitals."

Making hot dogs by the millions requires machinery and workers who know what they're doing. At Hofmann, the staff in the plant, where temperatures are winter cool, wear white outfits, rubber boots and hairnets. That goes for the boss, too. Like Rusty, they've probably been at it for

years. "We don't have a lot of turnover," the president explains. "People like the work and stay with us twenty-five, thirty years."

Hofmann's machinery is Swiss, stainless steel and operated by computers. Rusty says he has invested in plant improvements over the years, including new, computerized "smokehouses," which both steam and smoke dogs after they've been stuffed into casings. The Hot Dog King knows how to stuff a hot dog. He's worked through the business since he was a kid and played in his grandfather A.C. Hofmann's shipping room at the Hiawatha plant.

"I started working cleaning smokehouse racks summers when I was in college," he says. Rusty and his partners opened the first of three local Hot Haus restaurants in 1994, the year after the Platner family, owners of the landmark Heid's hot dog stand in Liverpool, decided that it wanted to produce its own hot dogs after grilling nothing but Hofmanns for seventy-five years. The family also began to add stands to what had been a one-shop business. Back then, a Heid's executive said, "The strongest will prevail, and the best operation will succeed."

In time, Heid's folded. The Liverpool stand has a new owner who sells only the Hofmann product again. Rusty is not willing to gloat, but we know who prevailed. All he wants to say about the so-called hot dog war is that he had a plan for restaurants in his back pocket as he negotiated with the Heid's people. "When he lost that account, we were ready," Rusty says. "We knew

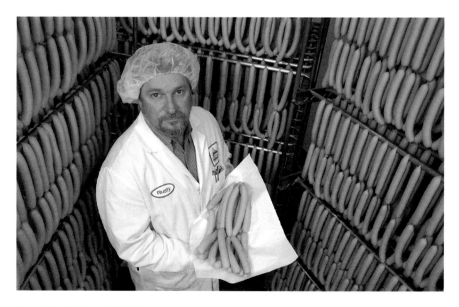

Rusty Flook shows off his hot dogs in the plant's inner sanctum.

to do it right, we had to do it ourselves." He has two daughters, both college students, who are the next Hofmann generation. "We'll see," is Rusty's answer to a question about a successor. "It's really prideful to hear someone tell me he's eighty years old and ate our hot dogs as a kid," he explains. "My goal right now is to keep the name going."

Originally published in 2003.

SAM, THE SAUSAGE MAKER

The Third Franciscan Order of nuns raised the first St. Joseph's Hospital on an airy drumlin called Prospect Hill, north of downtown, in 1869. The hospital—now a medical center—hangs in there after 135 years. So does a younger neighbor, the mom and pop butcher shop/deli run by the Donze family across from St. Joe's in the 600 block of North Townsend Street. Sam Donze and his kin have been in the block since 1925. "Lots of changes in the neighborhood," Sam says the other day as he eats a sandwich after the lunch hour's cooled at Donze's Too Pizza and Sub Shop (aka Donze's Grocery). Yes, good changes and not so good changes.

Sam's street mural is the busy flow of traffic on Townsend. He used to look out the front windows at a neat row of houses and Helen and George Schneider's bakery. Now it's the glossy wall of a hospital parking garage. He's chewing the fat with an old friend, Joe Pisani, who lives in Clay but grew up in the 500 block of Townsend. Back then, Joe's saying, "We played baseball in the street. All we had to worry about was the trolley cars; this was a mainline." These days? Well, Joe counts progress—the huge expansion of the medical center—a mixed blessing. "Prospect Hill used to be a beautiful street," he says. "But what the hospital does is important."

The hospital began receiving patients in a building at the top of the hill that had been a saloon and dance hall at East Laurel Street and Prospect Avenue. Expansion was quick, across three centuries. Today, St. Joe's main campus has fifteen buildings, meandering down the sides of Prospect Hill between Laurel and Willow Streets, north and south, and State Street and Townsend, west and east.

Sam Donze and Joe Pisani reminisce about the "old neighborhood," which included three schools near Willow and State: Prescott city school, the original Christian Brothers Academy and St. John the Evangelist parochial. All are gone now, in an effort to clear land for hospital parking. Sam's parents—Italian immigrants Mike and Lena Donze—planted the family flag in the neighborhood in 1925. Mike bought out an existing grocery.

Sam gives us a short history lesson. The original "Little Italy" thrived at the base of Prospect Hill, spreading south to the Erie Canal and west toward West Belden Avenue. "We moved in, and the Germans moved out," he says. "They moved up north on the North Side."

Mike Donze, like his son, was a butcher. He turned Donze's into a full-line grocery. The family—including Sam, his brother, Nunzio, and sister, Bessie—lived behind the store. The house is still there; Sam rents it. The store got bigger over time, but "meat was the thing," in Sam's words. After his dad died thirty-six years ago, and the "big chain markets were moving in, we changed over to a deli."

Mike Donze refused to join the Midstate Markets co-op, which his son thinks was a mistake. "He wanted to stay independent," Sam says, "but with them, you got better prices and the advertising." Sam and his brother earned their aprons stuffing pork into Mike's grinder and then turning the crank as Mike fed the pink meat into casings of pig intestines.

The Donze's Italian sausage tradition goes on at 618 North Townsend. Sam ground forty pounds the other afternoon as I watched. He makes it four times a week, clearing about three hundred pounds between Monday and Saturday. "We do a pretty good business with our sausage," he says with a big smile. Our man is proud of the heritage he's keeping. Sam mentions more than once that he uses "only 100 percent pure pork butts," which he buys from Oneonta Meats in Eastwood, a shop he calls "one of the last small meat distributors we have."

Sam's sausage draws former neighbors to the neighborhood, folks who've moved out of the city but return for a package wrapped in white butcher paper and tied with string and, according to Joe Pisani, for "Sunday Mass at Our Lady of Pompei" Catholic church. Sam's wife, Rose, joined him in the store fifteen years ago. She's an Iacovacci, from McBride Street. They'll be married fifty years in May.

Sam tells me he's turned down offers to buy the place. Coming up on seventy-eight years old, our man's a senior citizen but far from worn out. "Coming here gets my wife and me out of the house," he explains. "It helps, believe me." The Donzes have one child, Suzanne, a teacher at St. Rose of

Hot Dogs and Sausages

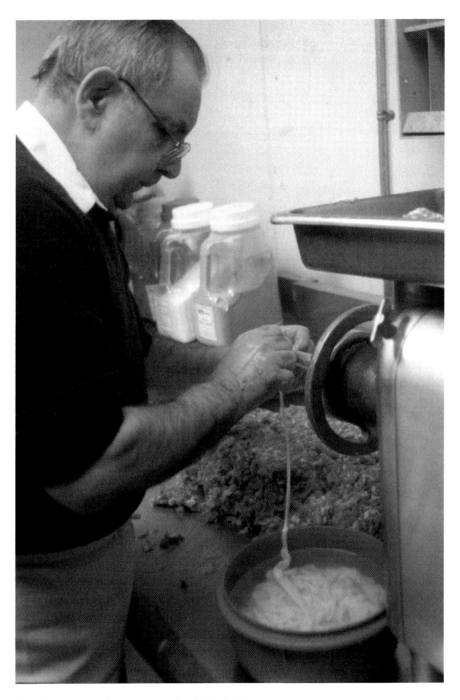

Sam Donze makes famed sausage in his North Side grocery.

Lima School in North Syracuse. Sam grins when I ask if Suzanne makes sausage. "No, after us, that's it," he says. "But I'm not ready to sell yet."

Originally published in 2004.

GIOVANNI GIANNELLI

The job's done. There are smiles and then some in the 100 block of Mary Street on the city's North Side. Easter's coming. A wood and plaster figure of Jesus Christ on the cross is snug in the bed of Reverend Mark Hughes's blue pickup truck. The statue is well wrapped in plastic and foam, ready for the trip home. Giovanni Giannelli runs a finger across the big package.

"Don't drop," he says to Father Hughes, who's been on the road from Washington, D.C., for seven hours. It'll be seven more before he's back at St. Gabriel, a Roman Catholic church on Grant Circle Northwest. "It's in good hands," the priest replies. We look around and nod. Everybody knows the precious figure that's been at St. Gabriel maybe seventy years has been in good hands the last five months, in Giovanni's busy, cluttered shop around the corner from Park Street. "The grand finale," Ray Pelkey announces with a flourish. "We can't wait to see it back at church again."

Grand finale plus one: two days later, a week before Holy Saturday, the figure—restored after an arm fell off more than a year ago—was lifted to a wall of the St. Gabriel sanctuary and bolted firm again. It's to be rededicated at Easter Masses today.

"Oh, it's absolutely beautiful," said Ray Pelkey on the phone one day last week. "So bright and clean." Ray, a former Syracusan in the St. Gabriel congregation, got the figure to Giovanni's shop and paid for the work. His twin brother, John, of Syracuse, sometimes helps out there. Ray is a retired Washington florist whose clients included the White House. He has lived in the district since he was stationed there during World War II. He came to Syracuse a week ago to see the figure wrapped and on the road.

St. Gabriel started out as a mission church in the 1920s with the Passionate Fathers order. The building today is considered a Washington landmark. It opened in 1932, probably with the crucifix in place. From what Father Hughes and Ray have been able to learn, the figure was donated to the new

church before it was finished. Giovanni Giannelli, who came to Syracuse in 1973 from his native Florence, Italy, believes it was made by the masters of gesso plaster in the city of Lucca.

Giovanni himself is a master woodworker. He learned his art at his father's workbench in Florence. Alfredo Giovanni restored architecture. "My daddy had a little shop and he did work for churches, plaster and ceilings," Giovanni explained one day in his own shop, Bottega Artigiana Antiques. "I helped him out. When I was in fifth grade, I was looking in the window of an old woodcarver in the neighborhood. He told me to come in. I started working with him. He showed me how to use tools."

Giovanni's a master of old and new. He may use electric tools for some work, old hand pieces for other. He knows when the fit is right. He reaches for a wood chisel that looks as if it's been around for two centuries. "My father's," he says. For thirteen years, Giovanni apprenticed at the famous Leone Cei in Florence. Among other work, he carved the tabernacle for the "Dome" in his home city. In 1960, he won the International Artisan Competition.

Giovanni came to us from Italy with the help of friends who recognized his talent and told him there was a carving job waiting at Syroco (Syracuse Ornamental Company) in Syracuse. Adolph Holstein, who started the company in 1890, was a carver of wood himself. Thirty years ago, Syroco still needed artisans to create molds that the company used to form its ornamental pieces. A mix of wood, flour, waxes and resins was pressed into molds to create replicas.

Giovanni says he carved many of these forms while at Syroco. New markets and changes in ownership—the Holsteins sold the company in 1971—gradually eliminated the need for a master carver. Syroco now molds with plastics. After he retired, he opened his own antiques and restoration shop, while taking a few freelance carving assignments that came his way. His wife, Lorrenga, has a dress shop in Fayetteville.

Ray Pelkey has been a member of the St. Gabriel congregation for more than thirty years. When the crucifix was taken down after the arm dropped to the floor, he tells me he knew it had to be repaired: "I said to myself, 'Jesus has fixed many a broken arm, now it's time to fix his.'" He says he knew just the man to do it. Ray was introduced to Giovanni by his brother, John. Both men collect antiques and used the shop on Mary Street for repairs and restorations.

"My first thought was to ask Giovanni to carve a new one," Ray explains. "But when he told me how much it would cost, I told him we couldn't do that. So he said, 'Bring it up. I fix.' That was the perfect answer." The master

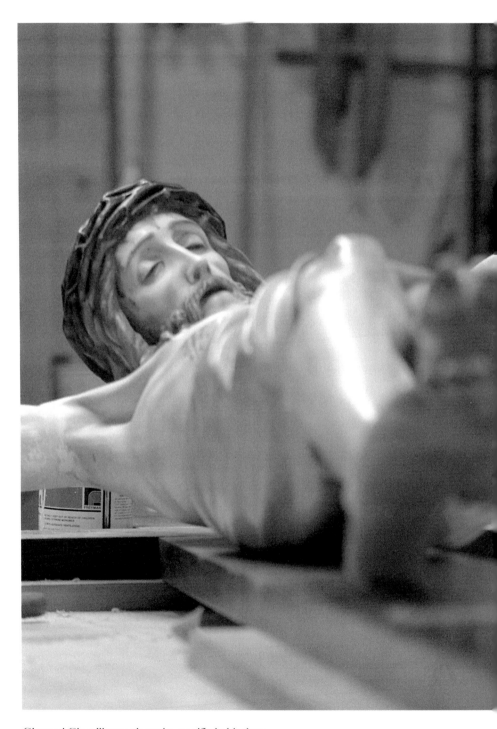
Giovanni Gianelli at work on the crucifix in his shop.

Hot Dogs and Sausages

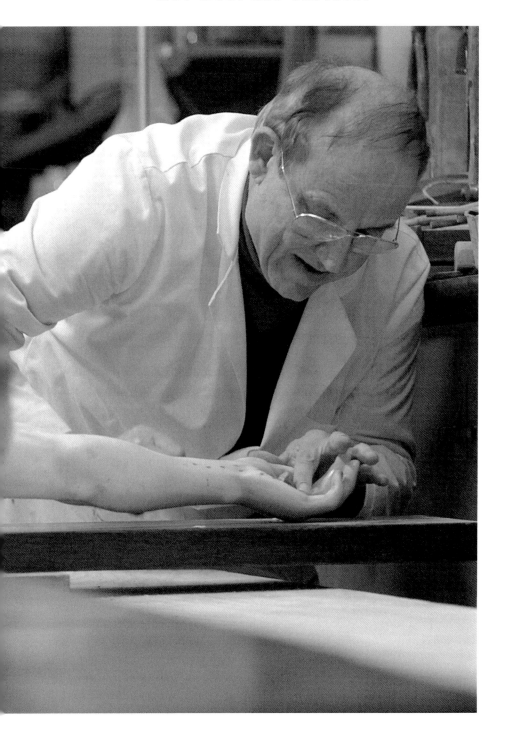

and his helper, Willie Connor, worked on the figure and the wooden crucifix for weeks, spelling themselves with other jobs. Much of the restoration depended on Giovanni's way with plaster and paint.

Willie, for his part, became enthralled. He served in the Marine Corps in Vietnam and has been a lay Baptist minister. Working on a Catholic crucifix was a new experience for him. He was delighted that the boss let him help. "He trusted me," Willie explains. "He raised the good in me."

Giovanni's assistant knows the bad of life. In 2000, his son, Jeffrey, twenty-two, was shot and killed in our town. He says the crucifix project changed him. "Working on this, I had a different feeling," Willie says. "I lifted that cross and I had a really different feeling. I was a different person. I looked forward to coming in here every day. I go around with a smile on my face." Giovanni listens and wipes his hands on his flowered apron. He smiles.

Yes, he says, this job helped him spiritually, too. It was something different: "At this time of my life, I work for enjoyment. I feel good about this." Spirit and body, it turns out. Giovanni's been diagnosed with liver disease. He travels to the Mayo Clinic for treatment. Willie reassures the master: you're strong; you're going to be OK.

Giovanni looks at Willie. He looks at Christ on the cross on the workbench in front of him. His eyes lift. "He's going to help me," he says.

Originally published in 2004.

BILL'S INN

Some pieces of the city seldom change. This is a good thing when we're talking about landmarks of Syracuse. Bill's Inn is a landmark of Syracuse. Except for a nine-year hiatus, it's been with us since 1921. Bill's opened five years before the Valley was annexed into the city. It was just over the line in the town of Onondaga.

Jimmy Smith is part of this tradition. For years, he's had a hand on those deep fryers that turn a slab of breaded haddock into the fish sandwich we made a local icon. He has owned Bill's since 1997 but worked at the restaurant in the Onondaga Valley neighborhood a dozen years in the 1960s and '70s.

Hot Dogs and Sausages

Bill's has changed locations in the Valley over the years, from a "shack" (Jimmy's word) along a little stream in the 3900 block of South Salina Street—at a corner of Valley Plaza—to a former soft ice cream stand at 410 West Seneca Turnpike, at Valley Drive. The fast-food menu endures: the "famous fish fry," hot dogs (Hofmann), fries, homemade salads and tartar sauce. Jimmy has added clam strips and onion rings.

Arlene Rockwell, of Onondaga Hill, is a Valley native. Her father took her to Bill's when she was a child. "Regular regulars," Arlene explains the other day as she and her husband, Don Rockwell, a retired air force pilot, lunch on hot dogs. They also drop in for Fish Fridays, like most of Syracuse south of downtown. Arlene knew Bill Helms, founder and namesake of Bill's, as well as his wife, Kate, their daughter Norma and son-in-law Paul Willey—all of them on the job at the little Salina Street building with a row of stools.

Bill, who died in 1957, bought a restaurant called Red Snapper Inn, next door to the original Bill's. When the Snapper burned, according to Jimmy Smith, the business moved to the "shack," where it thrived. There it remained until the Valley Plaza developer bought the place, and the Helms home behind it, and demolished them in 1988.

Jimmy's been cooking for us—he grew up on South Townsend Street—since he worked at Kresge's lunch counter downtown as a teen. He worked at W.T. Grant downtown before graduating into his own restaurants, including Smith's Sandwich Shop, a place in the West Taft Road medical plaza and Smith's All-Night House of Omelets on the North Side. Jimmy was at Bill's under Ed Klotz, who bought the Inn from the Helms family in 1964. He left in 1976 to start a catering business. The next owner, Robert Phelps, closed Bill's in 1988.

Jimmy says that even though Bill's was off the street, the customers couldn't let go of their appetites for fish frys. "They kept asking me, 'Why don't you reopen Bill's Inn?'" Jimmy says. "One day, my wife, Cindy, and me drove by and saw a For Lease sign on this place. Here I am."

Bill's Inn is family for the Smiths, who have six kids. Son Patrick is a regular worker. Mom, Cindy, whose day job is at Blodgett School, helps out on Fridays, when Jimmy cooks between 200 and 250 pounds of fish and 150 pounds of fries. The stand is open Monday to Friday, 10:30 a.m. to 7:00 p.m., but Jimmy needs to be there at 7:30 a.m. to make the salads and sauce. "It's a twelve-hour day," he says.

Last November, the twelve-hour days caught up with Jimmy. He was carried out of Bill's on a stretcher, the victim of high blood pressure. "I was ready to put the CLOSED sign in the window, but Cindy and Patrick stepped in." Jimmy's working his way back into a routine, but the day's about

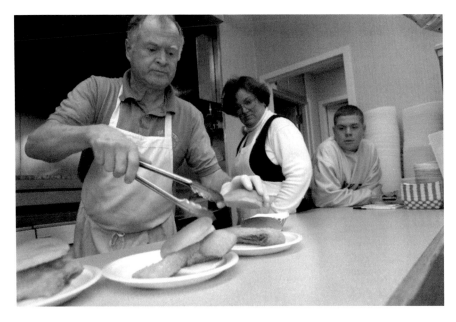

Jimmy Smith and family serve up goodies at Bill's Inn.

five hours instead of twelve this time. That's why, at sixty-five, he decided to sell the business; a deal is in the works that will keep Bill's "Bill's" and Patrick and his dad at the fryers "without the stress of running the business."

Just frying us fish? Jimmy nods. He assures us that we shouldn't worry about the prospect, which could happen as early as June. "I want Bill's Inn to go on," Jimmy says, mopping beads of sweat off his forehead. "The way it's supposed to go on."

Originally published in 2005.

SPRING STREET

Any searcher for the soul of Syracuse needs to spend time in the cozy dining room of Gilda DiCaprio's house on Spring Street, on the city's North Side. Spend it at the big table with Gilda (aka "Jil") and her sister from across

the street, Fannie Barber, savoring slices of the hostess's coconut cream pie, coffee and memories. Does it get any better?

Jil was born on Spring Street and never left. Fannie's been on the hill that climbs from Butternut Street for most of her nearly ninety years. At one time, three other sisters and their families were here, too. Their parents built this house and a two-family at the end of the block. When I arrived to talk to the sisters about their neighborhood, Jil took me to the back porch put up by Amalia "Molly" and Sam Emmediato, her parents, in 1938. The view to the west, gathering in the towers of downtown, is breathtaking, even on a cold, rainy afternoon. Below us the backyard drops toward Carbon Street in three terraces of fig trees, grape arbors and the remains of Molly's vegetable garden.

"There's no other backyard like this," Jil's saying, eyes flashing. "You never feel closed in."

Like lots of neighborhoods in our town, this used to be rolling farmland, reaching up steep slopes that define parts of the North Side, including Schiller Park and, at the end of Jil's block, John Street, where Gilbert Hill gets as close to the sky as most high points in Syracuse. That John Street hill holds one of our last brick streetcar pavements.

"They used to block off John Street and we'd slide on the hill in the winter," Jil says, the memories tumbling out of her and Fannie. "During the war, the kids from the neighborhood would sit up there at night when all the lights were out in the blackout. We had an interesting childhood." Memories of the movies shown on bedsheets in Phil D'Augustino's driveway; Phil's big telescope the kids got to use; the heady smells of Italian families cooking sauce mixed with sauerkraut brewing at Jake Borne's factory; kids carrying pails of fresh kraut home; dancing and singing in the Emmediatos' front room to the music of player piano rolls and Ma's Victrola; Jil playing her accordion; and walking to school and church up and down those hills.

Molly and Sam Emmediato come to life in their daughters' conversations as models of immigrants who work hard, raise their kids with tough love and put together a small piece of the action to be passed to the future. The North Side, more than others in the city, has a history that slides across several immigration waves: first the Irish, then the Germans, then the Italians and recently Southeast Asians. "Our parents said it was important to have your own home," Jil explains.

They had their first house on Spring Street built in 1924, about ten years after they met, married in their hometown of Salerno and immigrated to Syracuse. Later, they raised their second home, Jil's today, a few lots north, in 1938. Their daughters rented the original place for years and

only recently sold it. Meanwhile, Jil's family invested in a rental nearby on John Street. Number 100 Spring Street holds some of its original family ties, with properties owned by descendants of the early builders, including the Basiles.

Jil walks me around her house, with its compact rooms and woodwork stained by her father. If the kitchen had a voice, imagine the stories that would fill the air of thousands of meals cooked and family clustered at that table.

The woman of this house says she loves to cook and entertain, passions seconded by her sister, who used to work as a pastry chef (and at Dietz and Syroco). Jil explains that her mother was a fervent cook and entertainer, too, "and I feel an obligation to carry that on in my mother's house."

Molly Emmediato emerges as the centerpiece of a family that has blossomed into generations of children, grandchildren and great-grandchildren. My late colleague Mario Rossi called her in one of his columns "the indomitable Amalia." Jil and Fannie share stories about "Ma" attending Mass twice a Sunday and in between pulling a shift in Jake Hafner's vegetable patches in Liverpool, a job she had for more than forty years. Sam worked at Solvay Process. She tended to those terraced gardens of hers on the Spring Street overlook and presided over a kitchen where she made pasta, bread and wine, each said to be a "work of art."

Sam died in 1968, his wife in 1989 at the age of ninety-five. She's still a presence in her old home.

Jil says there's a spiritual "open house" sign in front of her place 24/7. One neighbor drops by for coffee almost every night. Every Sunday, she cooks a breakfast for her sisters and their families. Twice a month, her five children and their kin are there, circling the table, sometimes for one of Jil's polenta dinners. Fannie and Jil tell me they think Spring Street—surely their block—is in "pretty good shape" as a place to live. Butternut Street? That's another matter.

We probably wouldn't see these senior women walking to a neighborhood shop after dark, the way they once did. When one of her grandchildren is visiting, Fannie says, a daughter pleads to "keep an eye on her."

"It's the young people hanging around the street corners," Jil explains. Renters are another issue. Jil's had years of experience with apartment tenants; a sense of respect for property plunged over time.

"You wouldn't believe how some people trash an apartment before they leave," she says. "Thank goodness most of the landlords on our street screen their tenants carefully."

Not that the sisters think of leaving, as many of their former neighbors have. The bonds of neighborhood, family and memory hold fast. Jil smiles: "I'll never leave."

Originally published in 2005.

PART III
THE SOLDIER AND THE PRIEST

PASTOR JAMES

It's the middle of the morning and everything's in motion at 824 North State Street, around the corner from Butternut. James Gebhardt is moving racks of clothes out the side door onto the sidewalk. Joni Harris and her helpers are making sandwiches. Two visitors, a man and his wife, arrive with bags of groceries and clothing. Two guests wait for the coffee to perk.

"Regular day, serving the Lord," James explains, slipping into his crowded office, which is also a storage room and youth center. The last time I was under this roof it was Knodel Wholesale Meats, a family business that started in this North Side neighborhood in 1883. The Knodels closed in 1997.

Now I'm in Living Hope Christian Center, a nondenominational evangelist church that moved in six years ago and transformed the old meat market into an inner city mission where passion to serve rules. "This is servant evangelism," James Gebhardt tells me. "We're here to give people a hand up, not a hand-out."

"James" is Pastor James at No. 824. He founded this urban ministry about eight years ago as an outreach at nearby Frieden United Church of Christ. James is a recovering alcoholic and druggie who wears his gray hair long and often rides his Harley to work. "I look like the people in the neighborhood," he says.

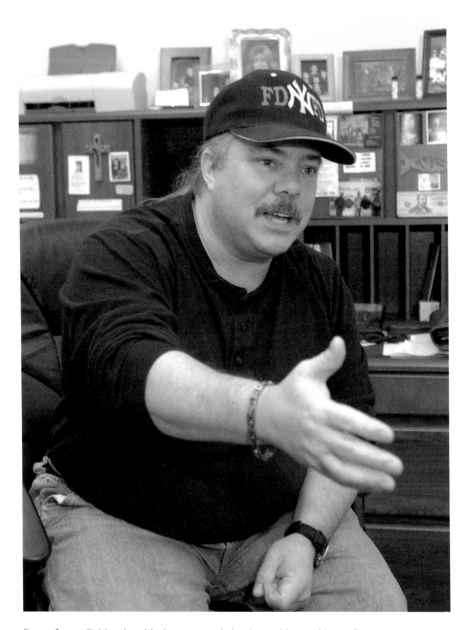

Pastor James Gebhardt at his downtown mission located in an old storefront.

The Soldier and the Priest

He got to this place the hard way (lots of personal demons put to rest) and wants to share his faith with folks he calls, with the understanding of someone who's been there, "garden-variety discards." There's a statue of Sylvester Stallone as Rocky on an office shelf. The image is deliberate, according to James: "Rocky was a nobody who became a somebody, somebody who got knocked down and stood up. That's my life story."

James and his helpers—including members and ministers from other churches—spent a year and a half converting Knodel's into a place of worship and service after the mission outgrew its home in the basement at Friedens. Now he says the center is outgrowing these digs: "We're looking for investors to buy a large building in the neighborhood."

The center has a daily soup kitchen—Cafe Jehovah—that sees between sixty and one hundred families a week, along with a Thursday night food pantry; Wednesday night and Sunday services; ongoing clothing and furniture giveaways; and special programs such as North Side prayer walks and festivals in Union Park. James figures his congregation has grown to about one hundred people, many of them citizens with issues whom he has met on the street. "Druggies, prostitutes, homeless folks, people with problems," the pastor explains.

"I call myself the 'outhouse pastor,'" James continues. "I want to be out there where people live: on the streets and in their camps," the shelters under bridges and in abandoned building the homeless fashion for themselves. When the congregation has something special going on, members usually hand out fliers door to door.

James grew up in LaFayette in a family with issues, which sometimes left him as the surrogate parent for his four siblings. From the time he was fifteen until his spiritual conversion at the age of thirty-one, he admits to being "captivated by drugs and alcohol." His personal moment of truth, he says, came as a custodial single parent when he realized he needed to reinvent himself. "Instead of getting high, I went to the most high," James says.

He was an associate pastor at Faith Chapel in Onondaga Hill before setting up a "basin and towel" ministry to the poor at Friedens Church. Along the way, he moved from being a lay pastor to recent ordination by the Elim Bible Institute in Lima, Livington County. Before that, James was introduced to human services as a member of the staff of a Syracuse group home operated by the state Developmental Center. James says regulars who've been attracted to Living Hope Center over the months that it has been open are not "church people" but "folks who feel comfortable here." There's no pressure to join the congregation, according to him, yet some guests do, often after James shares his own story of how "Jesus changes lives, like he changed mine."

The center gets referrals from county corrections officials, but most of the guests are drop-ins who've heard about the program on the street. James runs the operation with the help of a handful of volunteers and plenty of donations from church groups; he also buys from the Food Bank.

His board of advisers of local ministers and lay people includes the Reverend James Farley of Calvary Ministries, the congregation that sold its suburban church and moved into the city. "He's my mentor," James says. No. 824 includes a large sanctuary, where James sometimes shows videos to neighborhood kids, as well as a refrigerated pantry in the former meat cooler, Sunday school and nursery. The center's outdoor play lot is shared with the North Side Catholic Youth Organization on North Salina Street.

One of James's steady helpers is Joni Harris, a housewife from Howlett Hill who gave up a good job as an assembler at Welch Allyn Incorporated in Skaneateles to volunteer full time to run the soup kitchen, which is open from 11:00 a.m. to 1:00 p.m. every day. Joni's a study in bubbling enthusiasm, for the work and "my spiritual calling," which she says came about as she searched for "something else in my life" and met up with Pastor James.

Now she is convinced that she has a mission to "love up these people," as she put it, on the city's sometimes steamy and always interesting North Side. James is there, too. "I look forward to coming to work every day," he told me during a visit the other day. "I'm committed to this community and this city."

Originally published in 2005.

THE ARSENAL

Syracuse has a pocket of history hidden in a gnarly thicket of trees between East Seneca Turnpike and Arsenal Drive in the Valley section. The most fascinating treasure there is a story-high section of the cut-stone arsenal that the state built on the brow of a hill overlooking Onondaga Valley to store arms during the War of 1812. The Onondaga Arsenal was abandoned after the war; it has been coming apart ever since as a residential neighborhood grew up around it.

Lynn Coyle in old graveyard near her Valley home.

The good news this Independence Day weekend is that Dennis Connors, curator of history at the Onondaga Historical Association, is working to save what's left of this forgotten landmark. The bicentennial of the war approaches in 2012.

Photographer Steve Cannerelli and I were led by Lynn Coyle into the fascinating woodlot behind her Seneca Turnpike home one steamy morning last week. Lynn and her husband, Bill, who own a three-acre piece of the wooded area, have been there since 1979. "We have a grove of historic objects," Lynn explained as we climbed a path next to her house.

We saw what's left of the arsenal, the northeast corner. It sits at the edge of a ravine behind a row of homes on Arsenal Drive. We also saw an abandoned and overgrown cemetery dating to the 1800s, and the remains of a smokehouse, a limestone kiln and a stable. Except for the arsenal, all of these gems connect to the House family, farmers and quarriers who settled in the Valley two hundred years ago.

The House homestead, built about 1854, is at 382 East Seneca Turnpike. The last House on the land, Lucy, died in 1971 at the age of 102. We know this as the place where an 1864 naval cannon from the Civil War era points at the turnpike from the front yard.

Lynn and Bill Coyle (she's a retired nurse, he's a computer engineer) moved to their hillside aerie in 1979. The Arts and Crafts–style home was built by Mills Webber in 1915. From day one, Lynn explained the other day, the Coyles were captivated by their unusual house and the history that surrounded it. A few years later, they added to the lot by buying about three acres from Ralph Cleveland, of Baldwinsville, who bought what was left of the original House farm after Lucy House died. Part of that buy turned out to be the site of the arsenal. Ralph Cleveland still owns the parcel and says he's held onto it "to protect the historic value," even though the land is a possible target of a city foreclosure because of back taxes.

Cleveland's title to the arsenal is part of a confusing history of the site that Dennis Connors, of the historical association, calls "a mess." That's one reason Sheldon Ashkin, of the city Finance Department, says officials are cautious about moving to foreclose or selling the arsenal. City records list the owner of this lot as the Onondaga chapter of the Daughters of the American Revolution (DAR), an organization we're told was given the land by the state in the 1890s. The chapter disbanded in 1917, reforming as the Asa Danforth chapter, a group that denies ownership. Tax bills go to the DAR, in care of Ralph Cleveland, who says he has no connection to the group.

Dennis Connors says his research indicates the land acquired by the state to raise the arsenal in 1811 actually isn't where it was built. A survey by engineer Jack Cottrell for the historians in the 1980s revealed it to be 260 feet away on land now owned by Cleveland. That cloudy title, and the tax bill, persuaded the board of the historical association not to accept Ralph Cleveland's offer to give the arsenal to the association in the 1980s, Dennis says.

We know for sure that the Coyles own land around the arsenal, which is visible across the ravine when there are no leaves on the trees. Their lot includes the stone basement of the barn built for the House farm, a stone smokehouse and the remains of a limestone kiln.

Ed Schwartz is a Chicago police sergeant and descendant of the original settler, Jonathan House, a Revolutionary War veteran who came to Onondaga Valley from Vermont in 1804. The family later started cutting limestone in a quarry near the modern Brighton Avenue. Ed is fascinated by his family's history in the Valley. Two years ago, he walked the grove with the Coyles and made an offer to the city to buy the arsenal "to preserve it." He has not heard back.

The Coyles' property encircles the House family cemetery, a burying ground next to the family's home that's cloaked by old oaks and saplings and carpeted by myrtle. When they moved in, Lynn tells me, she and her husband accepted the volunteer job as caretakers of the cemetery that "nobody knows is here." Twice a year for the last twenty-six, Lynn says that, besides what she calls her own "mountain goat gardening," the Coyles have trimmed brush in the cemetery and worked to keep the place decent. Now they feel they can't do that anymore; they hope the city will give them a hand.

Lynn says that her main concern is the rotting oak that fell during a windstorm two years ago. It struck one of the three visible cemetery monuments, knocking off an obelisk shaft with a clean break. "It's awful, but there's nothing we can do about it," Lynn said the other day, standing next to the marker. The stone marks the burial place of Joseph Clark, who died in 1807 at the age of thirty-nine, and his wife, Hannah, who died in 1842.

Another old stone—the only one upright—is above the 1842 grave of Eunice Gage. A House family monument is flat in the ground and sinking. A list compiled by historian William Beauchamp years ago showed eight readable monuments; the cemetery likely holds many more, according to Ed Schwartz, the House descendant in Chicago.

Under state cemetery law, the abandoned burying ground is the responsibility of the City of Syracuse. Parks Commissioner Pat Driscoll told me last week that he'd check out the plot and "see what we can do." At the OHA, Dennis Connors hopes the city will consider foreclosing on the

arsenal lot and accept an application that he could prepare to make the landmark a protected city site. Oddly, that's never been done—locally or nationally—despite years of conversation about the arsenal.

Dennis said the city did that, at his suggestion, for the 1860s Geddes salt pump house site off Hiawatha Boulevard. That's good news to Ed Schwartz, the House family historian. "The arsenal needs to be protected," he says.

Originally published in 2005.

WACKY RAY

The next time you're in Paine Branch Library in Eastwood, ask to see the painting of "Wacky Ray." Then walk across James Street to the corner of Rigi Avenue and see Wacky Ray.

Ray Back is the guy who sells hot dogs and other goodies in front of James Street United Methodist Church. His pushcart driven daily from his home on Rigi has a sign that reads "Wacky Ray's" against a red, white and blue background that Ray says honors 9/11. This is Ray's first summer as Eastwood's only sidewalk vendor; he looks to have turned into a quick landmark. "This is good for Eastwood," says Rodney Trapasso, a neighbor who is Clay's animal control officer and a good hot dog customer.

Ray is a "100 percent disabled" navy veteran who grew up in East Syracuse and moved to Rigi Avenue thirteen years ago. He's retired from the Veterans Affairs Medical Center and decided to go into business for himself after checking out downtown's "neck to neck" food stands and thinking, "Why not do it in Eastwood?" He set up on the sidewalk in front of the church on April 1 and has been grilling dogs and sausages ever since, 8:30 a.m. to 5:30 p.m. "I'm here for the next ten years," Ray says. He claims to charge "Eastwood prices"; a dog on a bun goes for $1.25.

Wacky Ray got to be the star of an art exhibit after he was visited in August by Bill Elkins, a Syracuse architect on the prowl for a subject. Bill's been painting as a hobby for ten years and participates in Onondaga Art Guild's annual "Great Paint Out."

Rita Keller, president of the guild, explains that members pick a neighborhood and then fan out with cameras and sketch pads to capture it

as art. Wacky Ray has seen his portrait—it shows him serving a dog to two customers—and says he's impressed. "I'm going to buy it when the show ends" in October, he says.

I spent some time with Ray the other day as he served a steady flow of lunchers, flipping Hofmann reds and whites and Gianelli sausages, all the time keeping up the talk. He's wearing shorts and a Yankee cap and stands on a stool to bring him level with the grill. Drivers honk passing by or pull into Rigi for a fill-up. Ray greets everybody by name.

"This is a neighborhood place," he explains. "I use all local products, including Terrell's potato chips, and businesses around here help me. Some of my regulars help make change when things get busy. I go through ninety dozen rolls a week; the leftovers I give to the food pantry at Blessed Sacrament Church [down the street]."

Ray makes change at the Eastwood Barber Shop, across James Street, and keeps his supplies at the Fish Cove on Teall Avenue. He created his stand on wheels—with a salmon umbrella—with the help of his neighbor Lee Ernestine.

His wife, Bonnie, is his partner and business manager. She also cooks his daily supply of peppers and onions and helps get the stand up the street every morning. The can for tips? "Those go to my nephew, Keegan James. He's only two, but he helps out, too."

"Wacky Ray's" holds down the corner with the blessing of James Street United Methodist Church. "We're glad to have him," says Pastor Patricia Wayne. "He's a good neighbor." She credits the stand with changing the corner from a hangout for neighborhood kids who often weren't good about cleaning up after themselves. "Being there makes a big difference," the pastor explains. "He cleans up and even cuts the grass for us."

The stand is also Ray's informal sidewalk job agency. Two boys with fishing poles ride up on their bicycles. "I got them jobs at the Fish Cove," he says. When a guy in a pickup arrives, Ray tells him: "I've got a furnace job for you." Ray and Bonnie get up early to shop for the stand and set up by 8:30 a.m. Who's buying a dog at that hour? "The [Department of Public Works] crews from the night shift," Ray explains. "They all stop after work for lunch."

Bonnie's pleased and surprised by the way "Wacky Ray's" took off: "I never thought we'd be doing so good." As for the man himself, Ray thinks the stand is his contribution to renewing Eastwood. "We're picking it up, piece by piece," he says.

Originally published in 2005.

THE HORSE HIGHWAY

The Erie Canal made Syracuse a city, all the time cutting the community in half, north and south, and filling us with commerce, people and water for nearly one hundred years. Then it closed as a "horse highway" through town. We filled in the "ditch," saw the canal diverted to the north as the Barge Canal and invented a new kind of commercial strip, from DeWitt on the east to Solvay at the west. Erie Boulevard, layered on top of the canal, became the Erie's monument. Relics linger to this day. One just disappeared; another remains.

The Lynches are keepers of canal history. Until 2005, they had owned a strip of the Erie towpath—now the nine hundred block of Erie Boulevard West—since the 1880s. The last Lynch house was torn down and replaced with an auto repair shop last year.

At the turn of the twentieth century, there were some forty homes on what was still called "West Towpath," from the modern Geddes Street to the outskirts of Solvay. As far as we know, only one remains, a private home. Gloria Carey lives there, at 1772 Erie Boulevard West. Her house is at least one hundred years old, stretching back three generations in her family, the Wilburs. "I like it out here," Gloria said to me the other day. "No one bothers me."

The house, set back a few feet from the boulevard, originally belonged to her grandparents, the Bednareks, and then to her parents, Rose and Robert Wilbur. "Our family has been here more than fifty years," Gloria explains. "I grew up here, moved away, then came back. There used to be eight of us in homes in this block. Church and Dwight [the departed chemical company] bought them and tore them down."

Her family also bought another canal house next door, at No. 1770. It's been remodeled by the present owner, Kathy St. Croix, and her family, for their business, Drainman, a septic service.

I first met the Lynches in 1998, when Leonard "Bud" Lynch invited me into 912 Erie Boulevard West, once No. 3 West Towpath. Bud, a bachelor, was born in the house in 1923, the year after the city began putting down fill and pavement to create a new "Erie Boulevard" east of downtown. City officials bought five miles of the Erie Canal and two miles of the northbound Oswego Canal from the state in 1922, according to Andy Kitzmann, curator at the Erie Canal Museum. Roads were created in phases through 1926.

"We've been here a long time," Bud Lynch explained back then. "I'm the last." He died in 2002. His kin sold the house a year ago January.

The first of Bud's family to settle next to the canal were his grandparents, Sarah and Frank Castleman, in the 1880s. Sarah took care of mules for the canalers and smoked a corncob pipe. Frank farmed a bit and laid brick. The clan really dug into the towpath. In 1910, the city directory carried ten Lynches and Castlemans between Geddes and Genesee Streets. Bud's parents, Anna and John, raised six sons and a daughter in that little house.

The daughter, the late Mildred Gwilt of Bridgeport, told me in 1998 how her father threw her into the canal as a tot, after tying her to an empty five-gallon paint can. "He wanted to scare me but it backfired. I loved it," she said. Other family members shared towpath memories of skating from their home into downtown on canal ice, of canalboats tying up in front of the house and John Lynch's skill as a painter, musician and pigeon breeder.

In 1948, the *Herald American* published an interview with Anna Lynch and her brother, Ed Castleman, about their childhood on the canal. "Every night you could hear men singing as they drove horse and mule teams along the path," Anna said. "It's so different now, when all you hear is the droning of heavy trucks."

Ed recalled how he'd swim in the canal almost every day: "I would catch a ride on a barge, go all the way down to Geddes Street, and then swim back." Anna added that people in her clan never fell into the murky water that made for a front yard. Never, she said; only strangers did that. (Funny thing: Kathy St. Croix, owner of 1770 Erie Boulevard West, says that tax records still list her place as "waterfront property.")

Dino Caloia, of Cookie and Son car shop, bought the last of the Lynch lots in 2005 and put up a three-bay building, in which he plans to do auto detailing.

Eileen Marshall, of Cicero, grew up in the Lynch house at 912 Erie Boulevard West. She's Mildred Gwilt's daughter. Eileen said this week that the family regretted selling the place but "time goes by. My mother was the oldest of the seven Lynch kids. We lived there with my grandparents during World War II. I have a lot of happy memories."

We all do.

Originally published in 2006.

THE MYSTERY MAN

A fragment of my history in journalism came back to me last week. It's a piece of Syracuse history, too incomplete, it turns out. This happened with a phone call from Richard Holmberg in northern California.

Richard is a fifty-three-year-old mortgage broker who spent the first years of his life on sixty acres on Ransom Road, south of Jamesville Reservoir in the town of Pompey. Here, by Richard's measure, something happened "that destroyed our family." He still tries to gather the busted parts.

His father, Vernon Holmberg, thirty-eight, was a research chemist at what was then the State University College of Forestry at Syracuse University. On May 11, 1955, he parked his car on South Crouse Avenue, leaving behind the crutch he used while recovering from a chipped ankle bone but toting a briefcase marked "V.H." That was the last time we know of that anyone in Syracuse saw Vernon Holmberg.

Nearly seven years later, in February 1962, police arrested a man for drunken driving in Rockford, Illinois. He was fined $100 and spent six days in jail; he couldn't pay the fine. Fingerprints were taken of a man who called himself Verne Hansen. The prints went to the Federal Bureau of Investigation (FBI) for a routine check. The reply came back to Rockford: this man Hansen, who worked in a factory as a $1.90-an-hour paint mixer, was Vernon Holmberg, the missing chemist from Syracuse.

Vernon was Richard Holmberg's father. His call to me was a plea for help. "I'm trying to get some closure," Richard explained during our ninety-minute conversation. "I have four kids who don't have grandparents. They're at an age when they want to have a history." Richard struggles to provide his kids that legacy by trying to reassemble his own. It's not easy.

Verne Hansen was confronted by the reality of Vernon Holmberg in 1962. As far as we knew then, he denied it. The scholarly dad with a wife and three sons back in New York was declared by him to be a stranger. Don't bother me, he told reporters. I'm OK being a factory hand in this small town in western Illinois.

He seemed to die denying it. Cancer took him in 1985 at sixty-eight. He's buried in a Rockford cemetery under a marker that reads "Verne Hansen."

One of his son's missions is to set the record right about several things we may have read or heard. Richard says that there's little doubt in his mind that

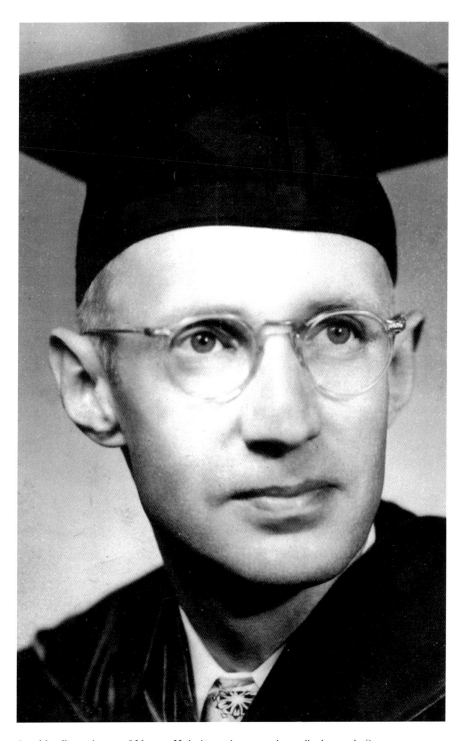
An old college picture of Vernon Holmberg, the man who walked away in Syracuse.

Verne Hansen knew he was Vernon Holmberg. Syracuse police handled the disappearance as a missing-person case. Back then, interviews with friends and family yielded few clues about why he was gone. Was it really amnesia? Or was a professor, known to be high strung and a drinker, leaving to get out from under stress in his life?

At the time, his wife, Dorothy, told her sons (Carl, Lee and Richard that their father had been killed in the Korean War. That myth held on until Verne Hansen turned up seven years later. Richard, who was two and a half when the man he calls "Vernon" left his life, says now, "He knew who he was. It was a charade."

Dorothy Holmberg, a schoolteacher and talented artist, sold the Pompey house shortly after her husband vanished and moved the family to her parents' home in California. She got a divorce and later married Gordon Babcock, an engineer. Richard says his stepfather was a reclusive and controlling man. Dorothy died in 1975, still talking about Vernon and "still loving him," according to Richard.

Two years later, when Richard was in college, he and his older brother Carl, a mathematician, made a surprise visit to the modest home in Rockford that Verne Hansen shared with his wife, Maxine. Richard says the visit was cordial and revealing to a son who never really knew his father.

The sons were shocked—"He looked like us"—but listened patiently as the man, then in the throes of throat cancer, asked questions about their lives. He played the small organ he had in the living room for them. Vernon Holmberg played the piano.

There were no admissions from the man, "just body language," Richard says. He and the older man later wrote back and forth, with still nothing of substance from the man called Verne Hansen.

There was one moment in that 1977 visit when his sons told their host that Dorothy had died; "we could see it shook him to the core," Richard recalls. "He still loved her. At that moment, I knew that something had gone on back in 1955; it was not his choice to leave." Later, Carl shared with his younger brother a stinging memory of Ransom Road: the time a few nights before their father left that "a group of gentlemen in dark suits" came to the house to see Vernon.

Who were they? Richard admits he hasn't a clue. Before he reaches the end of his search, he plans to ask for a Freedom of Information Act search of FBI records.

Originally published in 2006.

THE SECRET GARDENER

It was the sort of glorious fall day the gods pick to hang out their laundry, and there was Carol Bresee painting orange blazes on dead trees in Gray Park in Syracuse. Carol's crazy for the six-acre park at the western edge of Eastwood. She lives across Gray Avenue in Rugby Square apartments and adopted the swatch of grass and trees just off Teall Avenue last fall.

"This has been a blessing for me," Carol explains. "The park needed me and I needed the park." She's a recent widow for the second time. She moved to the Rugby from Auburn a year ago. Carol, it turned out, also adopted what neighbors call the "secret garden." She didn't know it at the time.

The garden is a lost Syracuse treasure, planted by a Rugby Road neighbor, James Burlingham, in the 1920s and gathered into this city green space when Gray Park was created in 1953, five years after the apartments opened. Burlingham, an osteopathic physician from England, was an ardent plant hobbyist. At his death in 1939, he was recognized as a world authority on mountain plants.

He created the garden on an acre of land at the north end of his backyard, landscaping it with evergreens and sculpting a small mountain slope filled with unusual plants that usually grow in climates and soils different from Syracuse's. He opened his "alpine garden" for tours; it had paths, steps, birdhouses, lights and arbors.

Carol doesn't think much remains of the Burlingham masterwork, except the special porous rocks and a few foundations. Like the rest of the borders of the park, it was overgrown and neglected when she started walking her dog there last fall. After the doctor's death, the garden was taken over by the Men's Garden Club of Syracuse, which held title in the 1940s. "It got to be too much for a group of volunteers," a member once told me. "We decided it would be better for the city to have it."

The club deeded the plot to the city in 1947, six years before the park opened. Gradually, the gardener's creation disappeared into the brush that grew up. Vandalism took a toll, too. Carol says a neighbor told her about the "secret garden" in Gray Park after she started spending time there. He directed her to an article on the Burlingham garden that I wrote in 1994.

Now the park is a full-time job for this neighbor, with no pay but plenty of payback. She's there with her yellow gardener's wagon and sensible shoes almost every day. When I called her cellphone last week, she answered in the park—it was raining and thundering.

"When I first started here, I was invisible," Carol says as we tour the park. "Now I'm Carol, the park lady." City workers who take away her brush piles tell her she's crazy "to do all this for free."

It's been close to a one-woman show, so far, according to Carol, who says that neighbors offer to help move her piles to the street. A group of volunteers, the Creek Rats, pitched in. Carol's also grateful for the help of Parks Commissioner Pat Driscoll, who is known to appreciate city neighbors who help keep our parks looking nice.

Carol trims branches with her small handsaw, cuts unruly brush, rakes, edges, makes compost and scours the park for paper and glass. "I've taken out five paint cans of glass so far." We're told that neighbors campaigned decades ago to keep the small park as a refuge of greenery in a residential neighborhood. Except for a volleyball field on the west end, Gray is pretty much a "dog park." Carol knows her neighbors—most by first names—and their dogs. She waves to two strollers. "That's Bob and Andy," she says. "Andy's the dog."

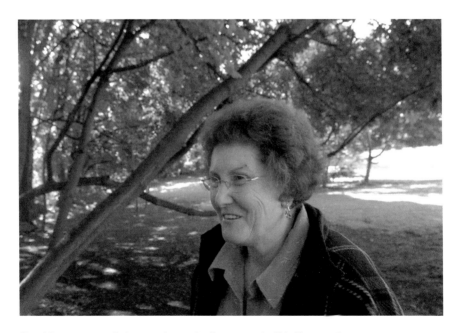

Carol Bresce pauses in her routine at the "secret garden" in Eastwood.

Experience this summer showed this volunteer that her work is appreciated—neighbors stop and tell her thank you. Carol thinks her work has made the park a more welcoming place; she aims to do more. Among her goals is to place benches in the park; she's had one donated and will put it out after she paints it. She'd also like to explore a modest restoration of what we once called "Burlingham Memorial Garden." She's talking to folks at the State University College of Environmental Science and Forestry about that. "And," Carol says with a big smile, "wouldn't it be nice to rename the park for James Burlingham?"

Wouldn't it?

Members of the Mildred-Peck-Paul Neighborhood Watch, near the park, want to help with garden restoration, according to Doug Greenlee of Peck Avenue, who facilitates the group with his wife, Mary Kay. Doug is in touch with members of the Burlingham family, researching the layout of the garden and a catalogue of its plants.

Originally published in 2006.

THE SOLDIER

The other night I stood in a neighbor's living room, listening to a political candidate talk about the war in Iraq. He'd been asked to share his thoughts on the mess we're in. Tuesday's election is about Iraq and just about nothing else. We're being asked to cast what amounts to an up or down vote on the war. The neighbor's house, and the coffee, was warm. The candidate hankers for a chance at public office. He thinks he can do better. He wants us to give him a chance.

My thoughts wander a few blocks to a family—unlike most of us—that lives every day with the realities of Iraq right here in town. MaryJo and Jonathan Bailey have a son at war in the Middle East; nothing will be the same for them until he's home.

Specialist Jonathan Bailey Jr. is twenty-three, an army gunner who signed on to a career in the military even before he graduated from Faith Heritage School in 2003. As the candidate spoke, Jonathan started his second tour in Iraq. He's at Camp Falcon, in southeastern Baghdad.

Two years ago this month, Jonathan was wounded in a suicide bombing of his Humvee. He was riding top gun. His sergeant died in the attack. This warrior of ours went to a hospital to be patched up—shrapnel left a scar just above one eye—then asked to be sent back to his unit rather than take an easier way out. He told his parents he wanted to be with his buddies; now he had a score to settle. Iraq's all about scores that need settling.

We could argue all night about why this lanky kid from Syracuse is in the Middle East. For Jonathan, understanding the war isn't the point. He's there because someone asked him to do a job. He does it. Over time, the job becomes a mission.

MaryJo Bailey tells me that she talked with her son and his fellow soldiers last week. They told her that whether they agree with the war or not, the people of Iraq deserve a chance at freedom. They are willing to give up so much "just so it will be made possible some day."

"Jon knows he may never see the good that will come out of this war, but he firmly believes that he is right where God wants him to be," she says.

Jonathan is the firstborn of the Baileys' six children. The house on Bellevue Terrace is busy, noisy and filled with love when he's home on leave. He spent a year in Colorado before the second tour took him to Iraq. The hardest part is knowing he's going back, according to MaryJo. Then the Baileys start again "counting the days until he's home… for good."

War ages her son, according to Jonathan's mom:

> *At twenty-three, he's seen things I can't imagine and he's aged well past twenty-three; the war has changed him. He's harder and colder. But he is still a trusting man who knows that our president is doing what he believes is right. I may not agree, but who am I to argue? I have never been in a war zone.*
>
> *I just hope these politicians think—and I mean think—about what comes out of their mouths before they speak and think of all the wives and families of the soldiers who are over there. They have no idea what it's like. Ask me and I would gladly tell them what it feels like and how much it hurts to know he may not come home.*

This election's got Iraq written all over it. Since most of us are distanced from the political system, voting is the only way we have to approve, or disapprove, of what's happening. The bitterness that goes with it speaks to the divisions that the "war against terror" leaves among Americans. Sadly, all of the energy of the last few months has been sucked into men and women

trying to get elected. None is left to deal with the awesome challenge of removing us from a tragic situation.

Polls suggest that the war is the number one worry of voters in Central New York. So much so that some of us seem ready to vote out Republicans in Congress no matter how good they looked the day before yesterday and who the Democrat may be. Do we even know his name?

Here's one name we need to know: Specialist Jonathan Bailey, a lanky kid from Syracuse doing the warrior's work in the Middle East for us. He's out there on the receiving line of the war, while we argue back home and fuss over vote counts. There's a direct line between the voting booth and southeastern Baghdad.

On Bellevue Terrace, the soldier's mother, father, brothers and sisters are "back in the routine," mom MaryJo says. "You know the one: sleepless nights, thinking all the time and praying he's safe. I find myself dwelling over his injuries from 2004 and hoping we don't go through any of that again."

It's up to the rest of us to pray, and vote.

Originally published in 2006.

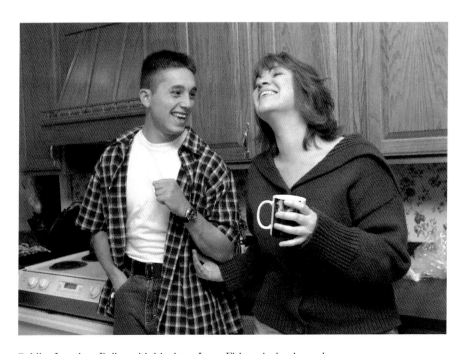

Soldier Jonathan Bailey with his sister, Lynn Fisher, during home leave.

FATHER JOE

Reverend Joe Champlin seldom lets me down when I ask him what he's working on. The pen is never still in its travels across the yellow legal pads that my friend fills with words. Last week when I posed the question, he answered that he'd just finished a manuscript for a new book, and another is ready to be published after the first of the year.

Father Joe is a Roman Catholic priest, scholar, expert in church liturgy, speaker, radio personality and writing machine. He's more than a year into a retirement that looks busier than when he worked his last assignment as rector of the Cathedral of the Immaculate Conception in downtown Syracuse, the so-called "bishop's church" of the Syracuse Diocese.

Just how many books has he written? The priest smiles: "Fifty or sixty, I'm not sure. I've finished six manuscripts since I moved out here." Total sales are in the millions. "Out here" is the parish house of Our Lady of Good Counsel Church in the hamlet of Warners, a cozy 1930s cottage not far from the main east–west railroad line across upstate New York. Father Joe, seventy-six, moved to Warners a year ago last July after completing ten years as rector of the cathedral. He brought with him a national reputation as a prolific writer and lecturer on subjects connected to his church and spirituality in general.

The deal Father Joe cut with trustees of the parish of two hundred families—which had been without a regular pastor more than two years—was to provide Good Counsel with a priest to say Sunday Mass and perform such ceremonials as baptisms and funerals in return for a home and office. For Father Joe, Warners means "isolation and quiet" and—his face lights up—"a garage for my car for the first time in years." The pace, he explains, isn't necessarily slower than before but different. "It's a better pace for me," he continues. "I have more time to pray and write. The work energizes me."

That work still includes a schedule of out-of-town lectures and parish missions. His personal reading is eclectic, including a biography of Pope Benedict and a Nicholas Sparks novel.

Father Joe works in his second-floor study, a room filled with books despite the thirty cases sent to the Le Moyne College library from the cathedral rectory when he retired, along with thirty boxes of his personal papers to the diocese archives. The priest writes on legal pads—"I never learned to type,"

he says—and the manuscripts are transcribed by Ann Tyndall, his longtime assistant, who followed Father Joe to Warners.

His ongoing assignment is to write, and record, what he calls "spots," and his "meditations," sixty-second slices of one man's wisdom that have been heard on Syracuse's Clear Channel radio stations (WSYR, etc.) for the past six years. The series, under the banner of the Guardian Angel Society that he founded to support Cathedral School, is so popular that it has been collected into two books.

The latest, *Take Five*, is just out with one hundred meditations. The first collection, *Slow Down*, came out two years ago. Both were published by Ave Maria Press, a company based at the University of Notre Dame that published a number of his books, including the first, *Don't You Really Love Me*, meditations on love and marriage, written in the 1960s, when Father Joe was assistant rector at the cathedral.

The idea for the spots originated with Paul Cowley, a Syracuse advertising executive who was one of the founders of the Guardian Angels. He and the priest took their idea to the radio station, and later a Clear Channel focus group, where the project was shaped into its present format of spiritual suggestions to help listeners cut back on stress. The first one was about a cardiologist who meditated.

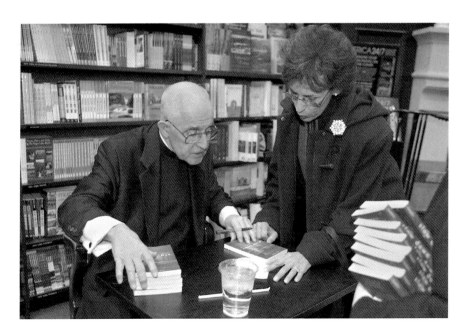

Father Joe Champlin at a Syracuse book signing.

Father Joe has written about three hundred since then. He recorded six at WSYR last week. They are broadcast in prime time and elsewhere around the schedule. And, starting last week, they are also played on satellite radio over the Sirius service. Joe Zwilling of the Archdiocese of New York City said the spots will be part of a new "Catholic Channel" (Channel 159), sponsored by the archdiocese.

Father Joe laughed heartily when I told him he now is "out there in space" with Howard Stern, the controversial talk show host also featured on Sirius. No big deal. Last summer, Joe was awarded the president's Volunteer Service Award by George W. Bush. More recently, he signed copies of *Take Five* at the House of Representatives, and jazz master Dave Brubeck, who also had a "Take Five" in his repertoire, wrote an endorsement for the book jacket.

Originally published in 2006.

NICK, THE BARBER

I watch the artist at work at 3012 James Street. Nick Morina has been all over our heads for more than sixty years. His tools this time are scissors and a comb. He gently lifts the client's hairs, cuts and lets them fall to the head. Then he steps back, gaining perspective, at the same time flicking lost locks to the floor from the comb with the scissors. A pile of dead cells grows.

Nick's studio is a small, busy cubicle at the rear of Eastwood Barber Shop—like Nick, a landmark of the neighborhood and our town. The place has three chairs up front, with a view of James Street, and three in back, where the boss may pull an orange curtain across the doorway if he's touching up a customer's hairpiece.

Nick cuts by appointment these days. His partner, Ron Gilmour, another veteran Syracuse haircutter, tends to the walk-ins at the front. Today, there's a big banner stretched across one wall: "Congratulations, Dad, for 60 years of service to the Eastwood community. Nicki, Gilda, Anthony, Francine, Gerard, JoAnne, Bridget, Teresa."

Nick smiles. "From the kids," he says. "We had a little get-together here the other day. The children, the grandchildren. The only one who couldn't

make it was my son who's in Moscow teaching the Russians how to make TV soap operas." (That would be Anthony.)

Yes, Nick's into his sixty-first year as proprietor of Eastwood Barber Shop, on the Midler Avenue corner of James. He took over the business from Dom DiPaulo in 1946. He says he has no plans to retire: "I've had a good run here."

For sure. Nick came to us from Sicily with his family at fifteen, an impressive resume already in place. His father had him train with a barber and a tailor in the old country and sent him to music school, where he mastered the sax. An early job in Syracuse was at Learbury clothing company, cutting and sewing. When he was drafted into the army, he went to Europe, where he "cut officers' hair." "That saved my life," he says.

Nick and his bride, Mary, moved to Eastwood shortly after they married. They're still there. Every morning, he attends Mass at Blessed Sacrament Church, a block from the shop, before "getting to work." Nick's friends say he's devoted to his faith. Ten years ago, at the shop's golden anniversary, he charged $100 a cut and then donated the money to the local Dominican monastery.

Among the family pictures, Sicily posters and stuffed pheasants on the walls of the shop are photos of popes.

Nick's devoted to Eastwood, too. "One of the best places I know to raise kids," he explains. All eight Morinas graduated from college and all but one—Teresa, a teacher at Eastwood's Huntington School—left Syracuse. "They went where the jobs are," he says.

Of course, the neighborhood has changed in sixty years and the Eastwood barber with it. Nick gets fourteen to sixteen dollars for a basic cut these days, and he's kept current on the ways we wear our hair, including the razor cut. Nick claims to have been the barber who introduced hairstyling to Syracuse, a skill that modern practitioners have to go to "beauty school" to learn; there are no more barber schools in New York State.

Business is good, according to Nick and Ron Gilmour, but it's been better, for this one and other traditional barbershops. Nick once had ten barbers working for him, at Eastwood and a shop at the city airport that he ran for fifteen years. Joe Nastri's in the chair in Nick's cubicle when I drop in. He's a partner in an Eastwood real estate company, a neighborhood native and a man who got his ears lowered here when he was a kid. Joe remembers coming to Eastwood Barber Shop with $1.50 that his mother gave him for a haircut: "The place would be packed; guys sitting on the floor."

Later, Don Broton slips into Nick's chair, which faces a small TV set. Don may be the shop's senior customer. He's been getting a trim since the

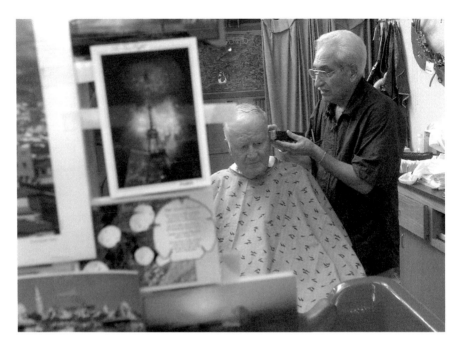

Nick Morina, cutting hair in his Eastwood barbershop.

days when Dom DiPaulo was the master barber. The Brotons were longtime Eastwood citizens. They recently moved to Liverpool but "still come back to shop and go to church."

Don said that growing up, "Eastwood was a neighborhood then. People move too fast now. No one's sitting on front porches."

Joe Antelmi stops by, too. He says he's Nick's oldest friend, back to the North Side and their army days. Joe runs an insurance agency in Liverpool and considers his pal "hardworking and generous."

In 1954, Nick bought the building that he's in; he sold it five years ago to his neighbors around the corner, Byrne Dairy. The Byrnes were turned down by the zoning board for their plans to expand. That would involve demolishing the shop and the vacant building next door. The boss is ready to move, if he has to. Yes, he'd find a new shop in Eastwood and keep on cutting hair.

"I can't stay home," Nick says to me. "What would I do?"

Originally published in 2006.

PART IV
FLOWERS AND NEIGHBORS

THE CANALBOAT

Loretta Lopedito has the Erie Canal in her blood. What's left of it sits in her backyard, on North Burdick Street near Fayetteville. Just now she's got her hands on a few pieces of paper that track her family's history on America's grandest public work of the nineteenth century.

Mostly the paper connects to her grandmother Agnes McGinley's kin, the Wrights, who look to have settled next to Burdick's Bridge, north of Fayetteville Towne Center, at the end of the 1800s. They settled on the canal and ran a store and tavern that are now history. Their house survives, across the yard from the ranch that Loretta and her husband, John Lopedito, built eighteen years ago.

The canal used to be Central New York's main line, as important back then as the Thruway is today. The leftovers are all over the territory, if we take time to notice. I got Loretta to take time the other day because of the low water in the channel that winds through Old Erie Canal State Park east of Syracuse. For the first time in years, we saw the sunken hulls of canal barges, particularly in the Lopeditos' neighborhood.

Fayetteville's all about water, by the way. We're talking Butternut and Limestone Creeks, the remains of the Erie and the Fayetteville Feeder, a modest water route cut between the Erie and the village, the better to move small boats into the community from the main canal.

The Wright family canalboat *Vermont*.

Water ruled there from the 1820s until the Erie closed in 1918. After that, as long as water flowed in the channels, the canals in the Fayetteville area supported local traffic. When the cuts shallowed and we found other ways to move goods, owners left their boats parked at the docks to sink. That's what we think happened to the "laker" barges seen between Burdick Street and the Limestone Creek aqueduct the last month.

Leaks at the Butternut Creek aqueduct that required damming are repaired. The water trickles again. One of the hulls sits in the abandoned canal just off Loretta Lopedito's yard. Experts tell us it's what's left of a ninety-seven-foot barge that probably ended its career with short hauls to Fayetteville.

We may walk there these days, parking at the west end of the canal park, at Butternut Drive, DeWitt, and taking the towpath east to Burdick Street and beyond. The park follows the old mule trail all the way to Rome, with plenty of access points on the way.

Loretta Lopedito has lived other places in fifty-three years of marriage, but she says that the family farm on North Burdick Street always "felt like home." As a girl, she spent summers with her grandparents—Agnes and Patrick McGinley—next to what we used to call "Clinton's Ditch." Agnes was a Wright, the family that kept the canal store, an annex to a house that still sits at the west end of the Lopeditos' lot, near Cedar Bay Road. Loretta

says that the annex was taken down in the 1930s. The family still owns the place; Loretta's son lives there.

Her great-grandmother, Catherine Wright, died in 1936, when Loretta was five. Today, she knows the Wrights mostly from fading snapshots and bills and letters that belonged to great-uncle Charles Wright. His papers documented his barge, *Vermont of New York*, hauling grain on the Hudson River to New York City.

A letter to Charles at Fayetteville Rural Free Delivery is dated 1928. One of the snapshots shows two men on the deck of the *Vermont*. Is one Charles Wright? The Lopeditos don't know if the boat in the canal connects to the Wrights. If the *Vermont* cruised the Hudson after this stretch of the Erie closed, it's unlikely that it is the carcass down there in the mud.

After I wrote about the boat on August 27, readers told me about two more old boats uncovered by the low water. They're less than a mile east from the first, at the edge of the "widewaters" just west of Limestone Creek. Folks called this "Hull's Landing," and Jake Huller, a Fayetteville native, recalls "jumping from boat to boat" there as a kid in the '30s.

I wandered past the wrecks the other day and crossed a modern bridge next to the venerable aqueduct, raised in 1851 to lift the canal above the creek. Fayetteville Feeder opened in 1826. The channel shows its age; we'd struggle getting a boat into town these days.

It's a pleasant walk to the outskirts of Fayetteville. The ditch ends near the Manlius town offices on Feeder Street, at the state dam on the creek. This neighborhood used to be lined with businesses, including limestone quarries and kilns, according to Manlius town historian Barbara Rivette. Barbara says that the houses left on the street are as old as sections of the feeder.

In the mid-1800s, Fayetteville was home to two dozen canalboats, sixty-two "boatmen" and a reputation as an agricultural distribution hub for the state. Today, the feeder path is a quiet, wistful stroll. I stop to chat with a neighbor. "There are only four of us [homes] on the street," he said. "It's like living in the country."

Originally published in 2006.

A LOST CHILD

Sarah De Maintenon is very happy this weekend. Happy and sad. She knows that the skeletal remains found on the Onondaga Nation thirty years ago belonged to her aunt, Melodie Rowe. She also knows that the district attorney of Onondaga County thinks she "most likely" was murdered.

Sarah, who lives in Oswego County, got in touch with me in 2001 about writing a column on Melodie, who went to the store and never returned to her home on the city's South Side in 1972. That was five years before the skeleton was found by a resident of the nation in a copse of trees near the dam south of Nedrow.

The body lay on a rug wrapped around the woman's torso, up to the neck. She wore penny loafers, a lavender top and two rings—one of plain silver, the other fourteen-carat white gold set with a mother-of-pearl stone. "It looked like she curled up and went to sleep," according to Tom Murfitt of LaFayette, a retired state police investigator who was the last detective on this case. Tom worked the case hard. Finally, in 1983, he concluded—with Norman Mordue, the prosecutor at the time, concurring—that there was no evidence of a "crime of violence."

The case was closed, on paper at least. What was left of the body, which had been kept at the medical examiner's office, was adopted by the congregation of a Roman Catholic church in Syracuse, St. Andrew the Apostle. It was buried in the family plot of a member of the church in St. Mary's Cemetery, DeWitt, under a marker that gave this "Jane Doe" a name, "Eve." The folks at St. Andrew reached out after I wrote about the plan to give "Jane Doe" a county burial at Loomis Hill.

Her niece, Sarah De Maintenon, told me Friday that the family plans to correct the name on the marker—perhaps even putting up a new one—and will hold a burial service for Melodie, who was seventeen when she disappeared.

State police notified her of the DNA match last week, before a news conference by the district attorney, who said that the remains had been exhumed from St. Mary's in 2005. Sarah told me she believes that connects to the column I wrote about her aunt's mysterious vanishing in 2003. Sarah was frustrated back then, after doing her own search, when she learned that this very cold case was listed as "closed," officially.

Tom Murfitt was surprised to learn of the new twist to the old case when I called him Friday. He was planting geraniums. His first comment to me was

that "there wasn't any DNA" testing done back when he recommended the case be shelved. Yes, Tom recalled interviewing the Rowe family (including Melodie's mother, Bernice Rowe) at their flat on Cannon Street as he chased leads in the case. He noticed the similarities in the shape of the face of Melodie's sister—Sarah's mother, Mary Anne—and the remains he was looking at in the medical examiner's office.

At the time, he was amazed—in sending an artist's imagined sketch of the woman's face to police agencies all over—that there were so many unknown women found dead. "I've never really put that case out of my mind," Tom said. He said he was surprised to hear that Bill Fitzpatrick, the chief prosecutor, now listed the death as a homicide, as it was the day the body was found by a man walking in the woods.

"If we had any idea it was foul play back then," Tom observed, "they wouldn't have us close it." A homicide's always open.

In 2003, when I wrote about Melodie for the first time, Sarah De Maintenon described the family's frustration at losing a child without ever knowing what happened to her. Melodie was listed as dead in her mother's obituary in 1996. Sarah said she first started searching for the woman she never knew when she was Melodie's age, seventeen. She told me back then that her aunt—a slim teen with long, dark hair—was "slightly autistic…they told me she was seventeen but acted as if she was twelve. She didn't have a ton of critical thinking."

"Eve" lies under a stone in St. Mary's Cemetery that identifies her as the "daughter of the community of St. Andrew." The arrangements were made by one of the parishioners, Nancy Murray, who still goes to St. Andrew. Nearly one hundred people attended the funeral at the church back in March 1983. Nancy Murray said she couldn't let this stranger go into the county's potter's field at Loomis Hill. "God knows who she is," she said.

Originally published in 2007.

THE FLOWER MAN

Blooms are busting out all over town. The man most responsible for this is Jim Cowburn, acting superintendent of the city greenhouse. Among other

things, he watches over 375 planting beds around the city. That's a lot of plants for a crew consisting of a chief and four people, but they're there for us.

I think Jim loves his job. "I'm not an arborist," he explains. "I do the best I can. I press a lot of flesh." That he does. The cellphone in his city truck rings a lot. He talks. He connects. He waves at passers-by. He waves at buses. "I know everybody around here," he exclaims.

Jim is married to the former Lisa Pollock, who teaches in the Lyncourt District. They have two young children and live in Strathmore. He says the family is supportive of his long summer hours—sometimes four in the morning until seven at night.

"Right after Mother's Day, we go crazy on plantings," according to Jim, who's in his fifteenth year as a city employee. He's been at the greenhouse for three. He took over from Alix Krueger, a city parks manager who supervised the area. Alix set the pace for putting plants in the ground all over the city, not just the twenty-six parks entrances we used to do.

Jim says he saw the number of brightened spots increase in Mayor Matt Driscoll's second term, up maybe by one hundred. "Now we add about ten a year," he says, dumping recycling bins of mulch on a refreshed bed in the median in the 100 block of Strathmore Drive.

The crew plants twice a year, spring and fall—tulips in the spring, which are put in the autumn before, and mums and azaleas in September. Many of the beds are in places that never flowered before, such as the median along the West Street arterial. The effect is startling, especially when we consider that Jim is running on a shoestring budget, helped by donations and other community gifts of plants and manpower.

Jim's boss, Parks Commissioner Pat Driscoll, admires the work of his longtime pal. "Jim's really stepped up," Pat told me. He says neighborhood participation is key with a slim parks budget to cover more than nine hundred acres of city parkland.

"We'll provide the plants and help people put them in," Jim explains, handling a call on his cell from an Eastwood neighbor looking for plants for Melrose Avenue. "Then we'd hope the neighbors will look after the beds." This usually works. Later, as we drive around in Jim's pickup truck, he points out community gardens that were abandoned by neighbors. This is sad. "Our people really care about the plants," he continues. "They nurture them, like little babies."

Their work centers on the city greenhouse on Onondaga Avenue, a complex of six connected buildings where it's pretty warm most of the year. There are rows of growing plants, piles of mulch, stacks of clay pots

Flowers and Neighbors

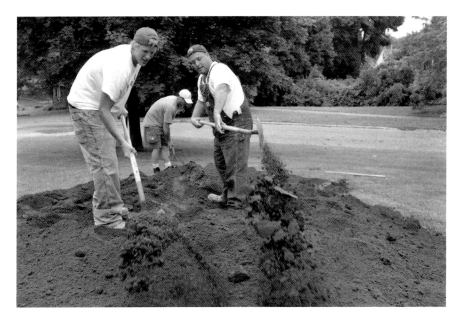

Left to right: Ryan Chapman, Paul Russell and Jim Cowburn readying a median flower bed.

and a cluster of large pots—Jim calls them barrels—filled with plants and ready for Eastwood's business district. Next door is a row of potted ferns—these are "stage plants"—which are moved around town for various city functions.

John Bialy is the main man at the greenhouse. He has worked this job for thirty-one years, starting under his uncle, Ben Kuppel, the legendary greenhouse superintendent who had the job for more than thirty years. John works with the stub of a cigar in his mouth.

Jim stops to check on Anthony Sokolowski, who's been on this job for five summers. He's loosening soil on the Strathmore bed before planting a rose of Sharon surrounded by lilies. The boss gives him a hug and says with his huge smile, "Strathmore's the model. Everybody says they want to look like Strathmore." He grew up nearby on Carleton Drive. He and Commissioner Driscoll got into the Strathmore neighborhood early to "make it look nice" for the annual homes tour on June 16.

Watering the beds was made easier a few summers ago when the Department of Public Works, a partner of Parks, came up with the idea of a 210-gallon tank moved around in the back of a pickup truck. Jim shows me finished beds and beds in progress in our quick drive downtown and into the eastern part of the city. Lipe Park—the new sculpture park on the West Side—is ready to plant. Fayette Firefighters Park and Forman Park,

the Museum of Science & Technology are done while Columbus Park waits for neighborhood helpers.

The Meadowbrook neighborhood is looking good, same for Outer Comstock, both with active community collaborations. Jim remarks that the South Side could use some green-up. He also hopes the Destiny USA folks will think about putting in some gateway plantings once that project comes along.

Originally published in 2007.

THE REAL "ALICE"

This is "quite a painting," in Jane Moynihan's opinion. She's talking about the "Alice in Wonderland" mural in the children's room of Beauchamp Branch Library, at South Salina and East Colvin Streets in Syracuse. The mural is close to Jane's heart. Seventy-three years ago, as Jane Mary Callaghan, age nine, she was the model for Alice. She came back to Beauchamp one day last week to check on the painting again and talk about what it was like to pose "a long time ago."

The painting was done by artist Ellen Edmonson in 1934. Her studio was a rented room in the 200 block of West Beard Avenue, in the block next to the home where Jane lived with her parents—Frances and Merrill Callaghan—three sisters and a brother. This was a public art project sponsored by the Works Progress Administration and the South Side Library Club. Jane's mother was an officer of the club.

"I don't know if it was Mother's connection to the library, or she [the artist] may have seen me walking by on my way to school at St. Anthony's [on Midland Avenue]," Jane explains. She had long, dark hair at the time, not Alice's sunny locks. "Artists can do anything they want to," Jane says. She recalls going to the artist's studio after school several times as Ellen Edmonson created the mural that now hangs above the fireplace in the library's children's room.

"I had to stand still for a long time and hold my hands a certain way," according to Jane, who doesn't recall how many times she went to the studio. She does recall climbing up on the mantel at Beauchamp during

the Christmas season of 1934, when the mural was dedicated. Her picture was taken. "I had on a green taffeta dress, for the season," Jane says.

The painting is titled *Alice's Adventures in Wonderland*, like the book, and is stuffed with Lewis Carroll's characters: the Cheshire Cat, the Queen of Hearts, the White Rabbit and the Mad Hatter. The original *Alice* came out in 1865. The author was an Englishman, Charles Dodgson, using "Lewis Carroll" as a pseudonym.

Jane's "pay" for posing was a copy of *Alice* that the artist inscribed to her as the model. She included a small *Alice* sketch.

In 1985, Jane brought her granddaughter Melissa, who lives in Maryland, to the library to see the painting. She gave her an Alice doll and her copy of the book. Melissa was about the same age as Jane had been when she was the model.

Jane lives in Onondaga Hill and is retired as an executive secretary at Community General Hospital. She worked there for twenty-five years, most of the time in the president's office. Before the painting took its permanent place at Beauchamp, it was exhibited at the Museum of Fine Arts and then located on the top floor of the city's Carnegie Library in downtown Syracuse. The show of Works Progress Administration public art also included work by three local artists: Frank Barney, Lee Brown Coye and Helen Durney.

Durney's art was two panels created for the dining room at Percy Hughes School. She did the original drawings for a book produced in Syracuse, *Dumbo, the Flying Elephant*, later produced as a Disney film.

Beauchamp has one of two murals created for city libraries. The other is a set of three paintings based on Cinderella, the Pied Piper and Jack and the Beanstalk in the children's section of White Branch Library on Butternut Street. These were created in 1928 by Margaret Huntington Boehner. White is the city's oldest library building. It opened in 1925 on the site of the original Franklin School. Beauchamp opened in 1929.

Originally published in 2007.

Jane Moynihan poses with the "Alice" mural at Beauchamp Library branch.

PRO'S GRILL

There's an empty space at 137 North Warren Street today. Pro's Grill was torn down Friday. We've lost another downtown landmark. Pro's (short for Procopio's) had been on that corner of North Warren and East Willow Streets since the 1960s. Before that, there was a gas station and a small office building.

The original barkeep was Peter Procopio. The family had been wetting whistles in the central business district awhile. His dad, Peter Sr., had the Rendezvous, a tavern in the 100 block of South Clinton. The license to sell liquor at 137 was surrendered to the state Alcoholic Beverage Control board on August 1. The building—was it the smallest bar in Syracuse?—was sold to the next-door neighbor, the partnership that owns 100 Clinton Square.

Yes, it was torn down in a day. The lot will be used to expand the company's parking lot a bit. Actually, half a dozen spaces were lost when a new bank drive-in window was added, but the owners gained space for more plantings, according to Joshua Podkaminer, speaking for the owner, Third National Associates. Pro's measured thirty by sixty feet.

Joshua says the plan is to expand plantings along Warren Street. He said Third National's main concern in buying Pro's was to remove an eyesore and "beautify the area" by demolition. Pro's was a hardy survivor, for sure. In 1973, a huge fire took out most of the surrounding business blocks. In 1976, Peter Procopio died. His wife, Stella, became the owner. We're told that Stella, who's in her eighties, is in poor health and turned over the day-to-day operation of Pro's to Peter, her son. The Procopios decided to sell the bar this summer.

Who could count the beers poured into our guts at Pro's over the years? The joint opened early—just the spot for an "eye-opener" in the morning—and stayed open late. Some cynical cops called the saloon "the armpit of Syracuse," which stood there, at the tail end of Warren Street, like a bad body part. For the patrons, though, this was home. This was family.

That Pro's was a place of warmth and comfort came through in 2000 when the grill was swiped by tragedy. Melody Walters, a thirty-nine-year-old mother of five children, drank enough to kill most people. She left Pro's and crawled into a "cardboard only" bin next door and fell asleep.

A few hours later, her body was found on a conveyor belt on its way into a recycling plant in Clay. She died of compaction injuries. Pro's

seriously mourned Melody. I stopped by before the funeral and talked with Stella Procopio, aka "Ma," a grandmother who owned great street wisdom.

Stella told me she'd warned Melody about the trash container, which didn't belong to Pro's. Stella said Melody didn't always pay attention to the people who cared about her. "Sometimes they don't listen to Ma."

In 1990, Thomas "Mell" Walters, Melody's dad, was found dead on a bench not far from Pro's downtown. They said he died of severe heart disease, complicated by lung trouble and alcoholism.

I'm told Third National Associates plans to build an enclosed trash container pad at the corner.

Originally published in 2007.

THE PHOTO SHOP

Shirley Savage works the late shift at Hendricks Photo Supply in Syracuse's Armory Square. She does this every working day. Shirley will be ninety soon. "Every day until 6:30, 7 o'clock," Shirley explains. "I do the banking, keep the books. I'm president of the corporation in name only. Petey's the boss here."

Petey is Shirley's daughter and business partner, Ellen Hildenbrand, who lives in Pennellville and needs to get an early start home. When she leaves after driving Shirley's car out front, the door is locked. If Shirley knows you, come on in, otherwise…

Hendricks is a bit of Syracuse history and a bit eccentric, as stores go these days. The specialty is hard-to-find items, most of it photo equipment. In some ways, the shop is a moment in time, way back somewhere, in a nice, friendly way. It looks like a country store.

The downtown committee believes that Hendricks is the oldest operating business downtown, 147 years and counting. It was started in 1860 as an art supply and frame shop by Francis Hendricks, a man who served two terms as mayor of Syracuse and was also a state senator and a force in the national Republican Party. A police heroism medal is named for Francis, along with an athletic field at Syracuse University. He donated Hendricks Chapel in memory of his wife, Eliza Jane.

Petey's great-grandfather, Irving Savage, worked in the store as a clerk, starting in 1880; he bought the business in 1916. Shirley took over after her husband, Marshall, died in 1961. In 1977, Petey stepped in and brought the store to Armory Square almost twenty years ago. Both women cherish the neighborhood. "I go to all the meetings of the Armory Square Association," Shirley explains. "I always make the adjournment motion."

Shirley's a major SU sports fan, too, always staying in her seat at the Dome (Section 243) until the playing of the alma mater at the end of the football game. She savors the ritual of lunch at the Sheraton and then the walk "up the hill" to the big covered dish of a stadium. In 2002, SU made her "Season Ticket Holder of the Year." She watches the Orange play basketball on TV. "You can see better," she explains.

Shirley's a university alumna, of course, class of 1938. She met her husband at an Adirondack summer camp while studying for her degree in physical education. She was a fine athlete in high school in her hometown of Wayne, Pennsylvania, a Philadelphia suburb, and taught in Rochester-area schools after graduation.

Shirley has a special chair at the back of the store, next to the signed basketball she got for her eightieth birthday. "I've been a housewife and a

Shirley Savage in her Armory Square photo shop.

schoolteacher," she says. "When I took over here, I had to go back to school to take business courses. I had to learn everything."

Shirley and Marshall raised four children at their homes in Lyndon, where she's been about forty years. Besides Petey—so called for her father's childhood nickname for her, "Peachy"—they are Gary, Jay and June. Jay's in Virginia, June's in Massachusetts and Gary's an operating engineer for Susquehanna Railroad who has regular runs in and out of Syracuse, as well as on the Adirondack Scenic Railroad. There are ten grandchildren on the family tree, as well as eleven greats and "more to come," Shirley says, expectantly.

Shirley's crazy for crossword puzzles, a hobby she says she's had since she was seven. When she's not doing the books, she's got one going, munching on a cookie as she fills the empty squares. She is, by the way, very accurate in her calculations, according to Petey, who adds, "She takes orders well, too." "It's good to keep your bean working," Shirley explains.

And the body. Shirley says she loves being downtown. In good weather, she'll wander the district, checking on things, picking up stray scraps of paper, neating up the landscape. This is therapeutic, too. "If you think you can't do it, you can't," she says firmly.

Originally published in 2007.

THE BASKETBALL TEAM

"We wanted to build something special here," Dan Queri is saying. I think he has. With the help of Kevin Frank, the pastoral assistant, he's revived the basketball team at St. Lucy Church, one of the anchors of the West Side of Syracuse. The team's up and running in its second season of competition in the Catholic Youth Organization League. "This isn't about basketball; it's about values," Kevin Frank says.

We're talking in the St. Lucy gym, which is as busy a place there is on the West Side. Kevin and Dan coach the team. We're at the end of the church's "Bread of Life" lunch: sandwiches, soup and other goodies given out to neighbors every Wednesday. No sooner is the lunch put away than volunteers

start setting the tables for a meal to honor the feast of the church's patron saint. It's an active, happy group, including Donna Rollins, a neighbor from Daisy Street who speaks Spanish.

The gym is strung with Christmas lights and looks good. It's across Gifford Street from the church and the St. Lucy clothing store. The food pantry is right next door to the gym and very busy today. All of this—all of it—reflects the Reverend Jim Mathews's philosophy of spreading the faith in a neighborhood that's among our neediest.

Dan Queri and Kevin Frank grew up friends in DeWitt, moved apart and then reunited a few years ago during a chance encounter at the airport. Kevin was working at St. Lucy by then and invited Dan, a developer who'd returned to Syracuse after a stint with Disney, to join the church. He did and has since become a pillar of the congregation.

Dan is a member of the West Side Initiative steering committee. Kevin says he had a "faith experience" while a student at Cornell and a member of a Christian fellowship group. He hired on as a pastoral associate, an unusual position in the Syracuse Diocese, after three years of working and living with the Reverend Ray McVey at Unity Acres, the rehab center in rural Oswego County, and deciding "I didn't want to be in a job where I wore a suit and tie."

Kevin is married and has four children and a divinity degree. His wife, Emily, works at St. Lucy as a coordinator of the youth Faith Foundation and the music minister. Kevin says he knew of Dan's interest in sports so last year he reached out to him for help in starting a basketball program. St. Lucy had been a stalwart of the old Parochial League, among Roman Catholic high schools in the community. The league existed from 1932 to 1976, when Catholic schools in the area began to close.

The Reverend Frank Sammons, director of the parochials, formed the CYO League in 1953. It's now directed by Mike Preston at Catholic Charities, who oversees twenty varsity teams, some of them carrying old Parochial League colors.

Kevin says his first step was to "open up the gym to the community" and recruit players from the neighborhood. Last season, St. Lucy put a team on the court; this year, the fourteen young players have taken hold, according to Kevin and Dan. They beat Blessed Sacrament in the first game.

"There was so much positive energy on that court," according to Dan Queri. It also helps to have a new electronic scoreboard; the old one was a series of flip cards at the scorer's table and a stopwatch. The new board was provided by grants from the Gifford Foundation and Central New York Community Foundation.

The grants also provided the team with new uniforms. "It means a lot to the boys to know they have the support of the community," Kevin explains. "They know they're representing the neighborhood out there with St. Lucy's across their chests." He thinks it means a lot to the kids on his team to play on their home court, with all of the excitement that goes with it.

Besides teaching them the fundamentals of the game, Kevin is concerned with keeping the boys in academic trim. At the moment, all are in school and eligible to play sports. He'll keep it that way, if necessary, by checking their report cards and providing tutoring. "We want them to win, of course," he goes on, "but to do it humbly. If they lose, they lose graciously. Those are the lessons of life." And, Dan Queri adds, "At the end of the day, it's great fun."

Originally published in 2007.

THE MEATBALL MIX

Marc Ascioti really throws himself into his work. "It's good exercise," he says with a big grin. We're in Ascioti's Meat Market, on Milton Avenue, in the heart of the village of Solvay. The store was opened ninety-four years ago on this very spot by Marc's grandparents, Antonio Ascioti and his wife, Catherine.

Marc's making the store's illustrious meatball mix, a product that's traveled the world, literally. He sometimes mixes it three times a day. Christmas week, the stuff flies out of the store. "I'm at the grinder eight hours," Marc explains. "It's a mob scene."

The recipe is Catherine's, Marc's grandmother, who also cut meat in the store. According to the "meatball story" told by Frances Quattrone, his aunt, the mix came about in the 1960s at the request of nuns at St. Cecilia Church. It includes ground chuck beef, cheese, water, salt and pepper, parsley, garlic, Italian bread and eggs in proportions that are still a family secret. Marc starts by grinding 150 pounds of chuck; then he churns in everything by hand. The stuff on the table in front of him he calls "the fluff." It's everything in the blend and smells heavenly.

The senior Asciotis—from southern Italy, by way of Philadelphia—planted the family flag in Solvay in 1914, across Milton Avenue from the Iroquois Pottery plant (now a China Towne store) because Grandfather Antonio was told that "Solvay needed a good meat market." His brother had a place at the other end of Milton briefly.

The store hasn't changed that much over time. It's dominated by the long meat cooler, loaves of Di Lauro's bread along on the top and stacks of mostly shop-made goodies inside, including Marc's sausage of all kinds and a line of Polish food from Hapanowicz Brothers Meat Market in New York Mills, the legendary home of kielbasa. "Everything's special here," according to Joe Cavallo, the market manager who's been at Ascioti's for thirty years and loves the work. Joe once had a Silver Star market in Solvay. "I always eat good," he tells me.

This is a thoroughly family business: small, cozy and prosperous. My hostess for the visits was Frances Quattrone, the founders' daughter who is retired as principal of Solvay Elementary School and lives above the store with two sisters, Fanny and Jesse. Fanny inherited title to the store from her parents.

Catherine and Antonio had ten children, six still living, and all were involved in keeping Ascioti's humming across the years. "If we need help, we call the cousins," Frances says. She works at a small table with a calculator at the front of the shop, checking out customers who exit with packages wrapped in white paper under their arms.

The meatball mix is definitely the bestseller, Frances says. During my stopover, one regular, Joe Anderson, of Jamesville, left with sixty-nine dollars worth of mix, headed for Binghamton, where he planned to drop off portions for the personal lunches of hospital workers on his regular route. "They fell in love with the product," he says. Another customer I had to swear not to name picked up her regular mix order, saying, "My husband thinks I make the meatballs myself." Like other clients, she rolls the mix into balls and freezes it for future use.

"Here comes another meatballer," Joe Cavallo says as Nancy Zanoni enters the store for a mix order, which Joe scoops out of the brimming tray provided by Marc Ascioti. Nancy says she's been a customer for "more than twenty years."

Marc shows me the business card of Robert VanHorne, another regular who walked out with forty pounds of mix packed in dry ice and headed for Thailand.

Peter Vilasi, Marc's uncle, managed the store most of his life. He showed Marc how to mix the meatball recipe. Marissa, Marc's daughter, sometimes helps out at the store, also.

Flowers and Neighbors

Judith LaManna, a Solvay native, mentioned Ascioti's in her book, *Solvay Stories II*, in a story about Pete (Vilasi) the Butcher: "He used to cheerfully sing out to me, 'What can I get for you today, Dolly?' I thought it was a special name for me but learned he used the same line with other girls. For adults asking for meat, he had a different line; he would look up, wipe his thick hands on his blood-stained apron and reply, 'I'll get that for you, my friend.'"

Frances Quattrone says she enjoys checking out orders and keeping the books at Ascioti's "because I love being with people." No, she says, the store's just the right size. "I don't think we need to expand," she explains. "I think we'll stop selling cigarettes when the stock we have is gone, but things are fine the way they are."

The store buys most of its meat from Oneonta Beef in East Syracuse, a longtime arrangement, according to manager Joe Cavallo, who says he moved to the store after Pete Vilasi promised, "I have a nice job for you."

He's an old-school meat cutter. "Most of the meat comes into stores these days all boxed up," he says. "Today, the handlers don't know how

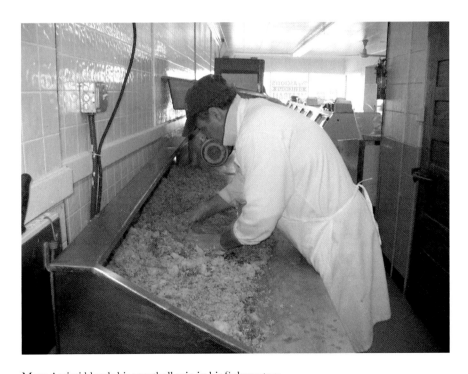

Marc Ascioti blends his meatball mix in his Solvay store.

to break down a side of beef the way we used to." That said, Joe dived into cutting one hundred pounds of stew meat for Coleman's Authentic Irish Pub.

Originally published in 2008.

THE GODFATHER

The kids are good to go right off South Geddes Street. They sign in and then step into the big boxing ring that rules the room. This used to be a McDonald's. Now there's no question of where the beef is. It's up there, inside the ropes. You can feel the energy.

I spent an afternoon ringside at the Syracuse Golden Gloves Athletic and Education Center on the city's West Side. Other folks may sit around a table and talk about the future of this randy, troubled neighborhood; these young people are working it out with their fists. "Controlled violence," Ray Rinaldi calls it.

Ray's the godfather of the idea of using boxing as a way of rescuing troubled youth in Syracuse. Fifteen years ago, he and his pals opened the nonprofit North Area Athletic and Education Center in an old laundry building on Pond Street. Three years ago, he gained a second building at 307 South Geddes Street, a closed McDonald's franchise. The guy who owned it—restaurateur Dominick Tassone (Dominick's Restaurant)—gave it to Ray as a gift.

In three years, he's turned the place into a Golden Gloves center, with lots of help from his friends. I went to the center because Ray's at a hard place. Two weeks ago, "I ran out of money. We had to stop work." We're talking about the big brick addition Ray's put on the original building. The annex would allow him to move the boxing ring into the add-on (the ring frame is there already) and use the front end for classrooms, where Ray's kids (he's got 844 on the rolls this week) would do their homework and other educational projects.

He could use a couple hundred thousand dollars more to finish the project, which is about 90 percent done, lots of that in donated materials and labor. Ray's standing in the annex with his hopes hanging out. He looks around.

"Who would ever have dreamed this?" he says to no one in particular. The man is a retired boxer and former furniture salesman who is seventy-eight years old and today, for the first time since I've known Ray, looks sixty. He's had a rocky two weeks, after falling outside the Pond Street gym and breaking his wrist and tearing a bunch of ligaments in his arm. Still, he's working out with the kids the best he can and playing catch-up with construction, which is tough for a guy with one good arm. He let up painting a wall when I arrived.

Ray's gifted at raising money for his projects. Sometimes all he has to do is smile and that messed-up kisser of his wins people over. He did it on Pond Street, and no one doubts this one will get done, too. "It's going to take off," his nephew, Chris Burns, says to me later. Chris is twenty-three and program director at Geddes Street. (Ray's daughter and partner, Christine, runs Pond Street.) Chris Burns was a decent Golden Gloves boxer. He has a political science degree from Le Moyne College and now is a full-time building manager, coach and trainer. Chris loves the work.

He sits in a cold office at the front of the center. He's the computer expert here. His latest project is a printout encouraging a partnership with the city school district, whose pupils make up about 86 percent of the rolls. About 20 percent of those are girls. He explains that the center focuses on at-risk youth.

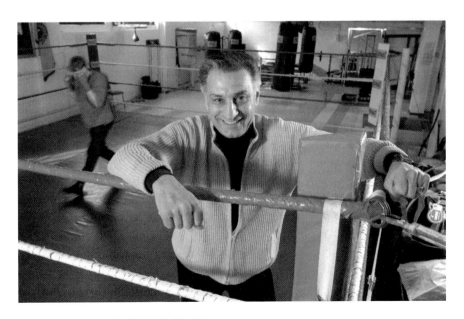

Ray Rinaldi in the ring in his Geddes Street gym.

"We draw in many macho kids who aren't attracted to team sports because of the toughness associated with boxing," he says. "We use boxing as a hook to draw youth in, then we try to change their lives through the discipline gained in boxing."

Many of Chris's kids are Hispanic, some recent immigrants to the United States with limited English skills. Chris works on that with their families and teachers. Fowler High School is right across Geddes. Close to 70 percent of the youths here go to Fowler and other West Side schools. Some are as young as eight years old, including the scrappy girl boxer nicknamed "Peanut" that I see sparring in the ring with the older kids. "They can get their aggression out boxing each other," Chris explains. "They go home so exhausted, they have supper and fall into bed…We're talking to the teachers. The kids bring in their report cards at the end of every marking period. Nobody gets kicked out of the program, but Ray may send them home for the day, with the promise they'll come back tomorrow."

Chris notices that their parents get involved here, too. That's a good sign.

A team of Ray's and Chris's kids will fight in the state Golden Gloves Tournament of Champions at the state fairgrounds in Geddes this Friday and Saturday. Chris Jones, Carlos Osorio, Dominick Vidal, Danny Alnutt and Bruce Dollinger qualified in the regionals at Elmira on March 29. Carlos is a U.S. champion at age eleven. Chris says two brothers, a sister and a cousin are also in the program. "They were among the first kids in the door when we opened in 2005," he's saying. "They were tough kids; now they are leaders."

Before long, the ring is filled with young boxers, sparring, yelling out commands, dropping to the floor to do push-ups, working out. Three minutes and then a minute break, by the bell. Then they get into gloves and work out on the bags, which hang from the ceiling around the gym. Later, they go outside and jump rope.

Coaches John Lautore and Frank Alagna keep them moving. Frank's got his baby son tucked under one arm. The Reverend Jim Mathews is a big fan of Ray's. He's pastor of St. Lucy Church, down Gifford Street from the center. He's written a check or two to the center, out of his own account. "Ray's done a wonderful job of getting kids off the street," Jim says. "They are into a discipline that will affect the rest of their lives."

Originally published in 2008.

TWO PILOTS

Charlie Greiner said his pal John Usiatynski had a good story to tell. He did. Just then we're sitting in Usee Motors, the car repair shop on the main drag in East Syracuse that John's had for more than fifty years. His nephew, Ray Usiatynski, does most of the repairs these days. John keeps the books. He's eighty-five.

Sixty-three years ago this month, John was a lieutenant in the U.S. Army Air Force, helping to fight World War II in Europe. He was a pilot, flying his P-47 on a bombing mission above a small town in Germany. His plane—nicknamed "Petite Monique" for a girlfriend—was attacked by German fighters. One he hit. The craft, a Messerschmidt, hit the ground and exploded. "I claim one Me 262 destroyed in air," he wrote later in an encounter report of the incident.

Last year, German aircraft historians doing research on missing World War II pilots found the lost fighter plane, buried about fifteen feet in the ground in a farm field in Bavaria, Germany. Remains of the German flier were still in the plane. John is recounting for us—Charlie, nephew Ray and other listeners—how surprised he was, last July, to get the news of the discovery. He was connected to the German researchers by Mickey Russell, a historian with the U.S. Air Force Historical Research Agency at Maxwell-Gunter Air Force Base, Alabama.

"Imagine that," John's saying. "Sixty-two years ago." And the memories come spinning back. He was a farmer's son back then, a graduate of East Syracuse High School who was drafted into the army in 1943. He had never flown an airplane. He really isn't sure if he had ever been in one.

"They had me take a test," John explains. "I guess I scored well, above average." The test put him into a military pilot's program. A year of training later, he was traveling across the Atlantic Ocean on the *Queen Mary*—"with a load of P-47 aircraft"—and into the war in Europe. "We traveled from England to France in a boat that fell apart when we hit the shore," he says with a laugh.

He flew out of a base at Toul/Ochey, France, in the 367th Fighter Squadron of the Tactical Air Command. His plane (he flew alone) carried two five-hundred-pound bombs. Before his last mission in June 1945, the young pilot from East Syracuse flew 105 missions, "most of them pretty routine," according to John.

The Army Air Forces pounded Germany in those last months of the war. "Sometimes," John recalls, "we'd go out twice in the same day." On April 8,

1945, he flew above Germany on an airdrome strafing mission, according to his report. He watched German planes go after the leader of the squadron and then his plane.

This was the way he described the dogfight: "I cleared myself and continued after him. We both were diving at fifty degrees. I gave him another burst at six hundred yards and observed strikes on his tail section. A few seconds later, he hit the ground and exploded." John shrugs, telling the story more than sixty years later. "It was just another mission. No big deal," he says.

Until last year, when he was contacted, via e-mail and telephone, by the German historians. They told him they had dug the plane he hit out of the ground—it was scrap, in many pieces—along with the bones of the pilot. That was when John found out the pilot had a name: Wolfgang Severin. Wolfgang was a corporal in the German air force. He was thirty-two years old.

Later John would receive several pictures of Wolfgang and an invitation to attend his funeral, which was held last September near his hometown in Germany. The remains were placed in a family plot in the village cemetery. "I couldn't go to the funeral," John explains. "But I did send a bouquet of flowers and a note, which had my condolences to his family." Wolfgang had a son.

Ex–World War II pilot Ray Usiatynski in his East Syracuse garage.

What did he say in the note? John can't remember the exact words but it was along the lines that Wolfgang, like John, was serving his country. John said he was aiming at the plane, not the man. It was war. All of the regret is drained out of it by now.

John came home to East Syracuse—there was no parade, as he recalls—and he and his brother Casmir opened the garage on Manlius Street, where he sits today. Eventually, he received the Distinguished Flying Cross for taking down that plane. Also the Air Force Medal with thirteen clusters.

Before they deteriorated, he used to show his family the films—his own story of the war—that were recorded by the camera in the nose of "Petite Monique." His nephew kids John: "One of them showed you firing on a guy on a bicycle." "He had a rifle," John replies. John served on the East Syracuse School Board and as commander of the Veterans of Foreign Wars. He also was an officer of the Lions Club. He had two daughters and a son, who died.

Mickey Russell, the military historian in Alabama, tells me it is not unusual to find a lost aircraft these days. There are people who recover the old ships, rehabilitate them and "sell them for lots of money." Yet finding the pilot's remains doesn't happen every day.

John Usiatynski will verify that. For him, it was once in a lifetime.

Originally published in 2008.

THE WARD

Shed a tear for the old Fifteenth Ward, a racially mixed Syracuse neighborhood that once flourished between Syracuse University and the east side of downtown. It was turf for blacks, Jews, Greeks, Italians, Lebanese and Poles before Interstate 81 cut the city into two neat but disparate halves. The Jews settled in about 1840; blacks, most from the South, arrived in the 1920s.

A few years ago, I lured a few alumni of the ward back home. They're on the committee that every other summer organizes SyraQue Reunion, a gathering of folks who grew up in the neighborhood. These men,

distinguished retirees all, stood next to Pioneer Homes, which stands as the result of the first upheaval in the neighborhood. One of the country's first public housing projects, Pioneer Homes opened in 1940 with 64 buildings replacing four city blocks and displacing nearly three thousand people and 314 homes and buildings.

Clarence "Junie" Dunham, who retired from AT&T Corporation and the Onondaga County legislature, was there. Also Billy Moore, who is retired from the U.S. Postal Service. Dunham stood on the sidewalk on Townsend Street, where he used to live at Pioneer Homes, and waved his arms. "They tore down our old neighborhood," he said, more in regret than anger. Moore nodded. "They destroyed the ward," he said.

They—the administration of the City of Syracuse—labeled the area a fire hazard, dirty and infested with rats. Officials said cobbled and illegal apartments had to be replaced, despite the protests of the people who lived there.

In their place, the Syracuse Near East Project, part of a federal urban renewal program, was created in the early 1960s. Over ten years, several hundred homes and businesses were demolished, displacing close to 1,300 people.

The cleared turf became Community Plaza, an area that's home to the Public Safety Building, the Justice Center, the John H. Mulroy Civic Center, the Oncenter, the Onondaga County War Memorial, the Everson Museum of Art and soon a convention center hotel. Later, in the mid-1960s, the construction of I-81 cinched the belt and, according to some people, divided a city.

Recently, I asked Dunham about the Fifteenth Ward. He hadn't changed his mind. "You saw the black preacher walking the streets when you went to the candy store. They knew your name; you knew the name of the guy who lived across the street," he said. "Black people were together. People stayed put. We lost the closeness. The community was great and it's gone."

They lost Wild Bill, Pee Wee, Moon, Neno, Feebie, Lemon Head Jack, Bad Eye and Snake. The Alcazar, the picture show, is gone. So is the ragman with his horse and buggy, Edith Harrison's store, Percy Harris running numbers, the Grand Street Boys, Sammy Davis Jr., dancing on a street corner and "Mother" Emily Moore. Jews and blacks, living side by side, getting along. "Our own little melting pot," Dunham called the Old Hood.

Author John A. Williams, a product of the neighborhood, wrote several books about the black experience, including *The Man Who Cried I Am* and *The Junior Bachelor Society*, said to be based on Williams's Syracuse experiences. Williams once put it this way: "The Ward was home and the rest of Syracuse radiated outward from it."

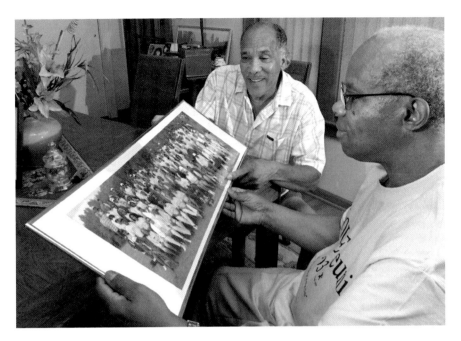

Clarence "Junie" Dunham and Marshall Nelson recollect their years in the Ward.

When the ward went down, residents took their housing allowances and moved outward, mainly to the east at first; later, to the south and west; and later still, to the North Side of the city. It wasn't any better, but it was different.

"The Jews moved east—eventually to DeWitt and Fayetteville—and the blacks followed them, to the east side of the city," Dunham says. Their institutions followed, too.

A few remain, including the Dunbar Center, on South State Street, where immigrants from the South used to go to find work. Everyone agrees that Dunbar, south of Adams Street, hangs in there, but it's not the place it used to be. A different role in the community has been taken.

Central High School, at Adams and Clinton Streets, was closed. It may be transformed one day but it's still closed. Also gone is the Boy's Club on Fayette Park, which moved to other neighborhoods and became the Boys and Girls Club. Dunham points out that Syracuse was certainly not unique in changing its black soul. "It happened everywhere, every city," he said. "We lost a lot."

Originally published in 2008.

2 ORANGE STREET

How the blood splatters. We're in a burst of violence. Neighbors, sons, daughters, mothers, sisters, brothers, cousins and acquaintances are dead. Others are in jail, their lives ended also. A community is in mourning. For our beloveds. For our feelings of safety, peace and trust of one another. Lower the flags to half-staff for lost lives, lost innocence.

I'm touched with blood this week. Cara Bryant was murdered in my grandparents' house in Marcellus. From August 2 forward, we have a new reason to recollect 2 Orange Street. Sadly, two killers gave it more history than an old house needs. There haven't been Cases in No. 2 in maybe fifty years. We're gone from the hometown—in the ground, some of us—yet we connect.

A Syracuse TV reporter called the place "a lovely Victorian," straining a contrast that should have stayed unspoken. It sits, as it has for at least 130 years, on a quiet street off the main drag of Marcellus, at the top of a yard that used to stretch to the banks of Nine Mile Creek. Aunt Lucy told of "walking down the lot" to skate on the creek ice when she was a girl.

We think the Cases, Harriet and Willis, moved in during the 1890s after the family's general store, N.G. Case and Son, folded. They had lived next to the store. Willis was the "Son" in the partnership. Harriet and Willis were my grandparents. They died before I was born. We see 2 Orange Street on the 1874 map of the village, marked "Lish Est." Likely it's older.

Hattie and Will raised six children in the house, two sons and four daughters. My father, Newton Giles, was one of the clan. Will had worked the store with his father. Later, he hired on as a night watchman at the Upper Crown Mill, on the creek at the end of Orange Street.

My memory rides a bike down the street: the Parsons sisters lived in the big, old house at the corner of Main Street back then. It had a yard filled with grapevines that stretched to the Case lot. There's a gas station now. Next along were the Rowlands, the Shayses and the Walshes. Across, the Cases lived next to Ward Curtis, who ran a hardware store upstreet. Next door, "Doc" Weidman's place; his widow lived there when I was a kid. After that, the two Moir homes. They ran the woolen mills. And at the corner, venerable St. John's Episcopal Church, where the Cases prayed. Will's father settled in the village in the 1840s.

Flowers and Neighbors

In my head, I could walk up on the front porch of 2 Orange Street and open the door, where I see a spiral staircase with a railing I wasn't supposed to slide down. I'd walk through the dining room into the kitchen and "backroom" and the door to the backyard. The living room, divided in two, ran along the south end of the house, with a screened porch to the side. I stood in that room when my cousin Harriet married Albert Matzel during World War II. Al was in army uniform, on his way to fight a war.

I'm reading the sheriff's department court information on the two men accused of murdering Cara Bryant, one "stabbing her repeatedly and slitting her throat," while his pal held a towel over her mouth "so her screams could not be heard." I hear them.

Did Cara die there, at the hearth, in front of the windows where the Cases used to wake their dead? Before they carried them to Highland Cemetery, a pathway this poor young woman would follow, too? These are truths only the ghosts know. Did they flee as well?

I know because I read in their obituaries again last week that Will and Hattie died in those upstairs bedrooms, that their priest from St. John's sang them to heaven from the front room. Grandpa Case, the *Marcellus Observer* dutifully reported, "passed away gently, surrounded by his family." Grandma, too, left "quietly." The living room had been filled with "flowers wonderful and profuse" during the service.

I remember when my "Aunt Moonie" died. I was two. I remember standing at her bed upstairs. Her long hair flowed across the pillows, the life left in her wispy and faint. They said Mildred, my father's sister, passed peaceably, too.

I can smell Aunt Lucy's fried cakes coming to life in a pot of grease in the kitchen, feel the cats—Yellow and Mitzi—rubbing against my legs. Hear the old radio in the front room and Aunt Mary and Lucy commanding silence as they sat down to listen to "Curly" Vadeboncoeur comment on the news during the lunch hour.

Cara's dying sent me up the apple tree at the end of the yard, next door to play with kittens at the Parsons house and across the street to sneak into George Walsh's barn. There's no blood to be seen.

Yet we live with violence, next door and across the world. It's in our heads and our headlines. From Israel to Pond Street, we stare it down every day. And try to make sense of it, a tough, frustrating challenge. Hear the neighbors yelling at the chief of police and assistant district attorney at North Side Athletic Club the other night.

Lock them up. Keep them in jail. Put more cops on the street. Answer when we call. Stand in front of the blades and bullets. What good are orders

Sheriff's department investigator photographs a crime scene, 2 Orange Street in Marcellus.

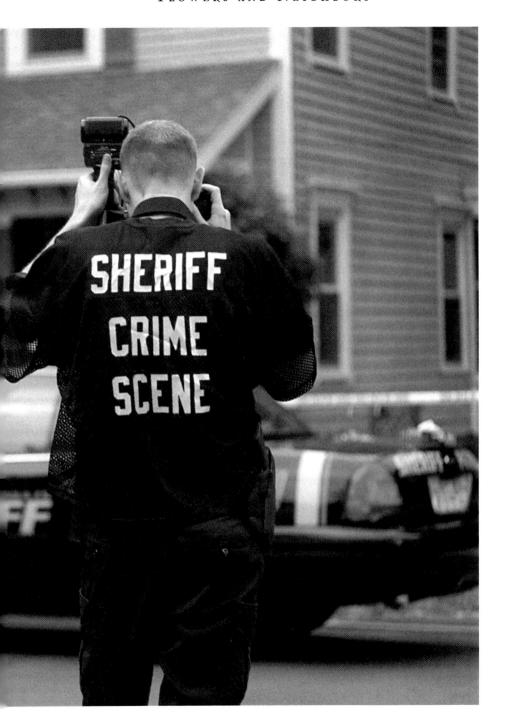

of protection? Bail? Anger management courses? Politicians' promises? Senseless, senseless, says the victim's mother. She's got the idea.

Blame the heat, the drugs, the booze, the parents, the gun supply, child abuse, a broken heart or defective gene? Society? Poverty? Racism? The nasty crossing guard? Look into the accused killers' faces during the "perp" parades at the courthouse. Do those blank looks show any answers? No. The chill is glacial.

So we rage. And wait up for the next one. Meanwhile, in the quiet, caring people reach out to try to help. The district attorney will look at drafting a better law to keep a repeat offender of an order of protection out of harm's way. Downtown movers and shakers go to the streets to talk to gang members about routes around violence. The police chief will move the troops around. Neighborhoods will organize.

The experts and the scorekeepers caution us not to lose our heads. The stats aren't spiking; ambulance calls, police calls, murders, even, are not above the norms. It's just that, well, our losing streak of late is so tragic, so bizarre.

That doesn't help much, does it?

I drift back to Orange Street and the family album. There's a postcard picture of my grandmother's brother, Harry Griffin, his arms around a huge sunflower plant in the backyard. Someone wrote on the back: "He was the one who had the stroke on one side. Paralyzed but lived with Grandma. We called him Muzzy and all he could say was 'Golly, Golly.' He set the homestead on fire with his pipe."

You understand, Uncle Harry. Stroke or no, all we can say right now is "Golly, Golly."

Originally published in 2002.